IMAGES
of America

SUMMIT
WISH YOU WERE HERE

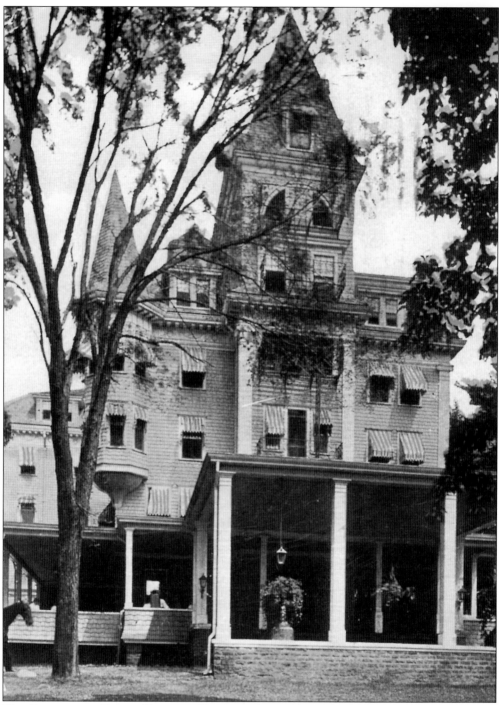

THE BEECHWOOD STOOD TALL AND PROUD. The Beechwood was the last of Summit's three large summer resort hotels to be razed. It came down in 1953 and was replaced by the Kemper Insurance parking lot behind De Forest Avenue. In its heyday, the hotel hosted 250 guests at a time. From its long, open-air porches, visitors at the turn of the century enjoyed views of the Beechwood's 4-acre piece of property.

IMAGES
of America

SUMMIT
WISH YOU WERE HERE

Patricia E. Meola

ARCADIA
PUBLISHING

Copyright © 1998 by Patricia E. Meola
ISBN 978-0-7385-6330-5

Published by Arcadia Publishing
Charleston SC, Chicago IL, Portsmouth NH, San Francisco CA

Printed in the United States of America

Library of Congress Catalog Card Number: 2008927307

For all general information contact Arcadia Publishing at:
Telephone 843-853-2070
Fax 843-853-0044
E-mail sales@arcadiapublishing.com
For customer service and orders:
Toll-Free 1-888-313-2665

Visit us on the Internet at www.arcadiapublishing.com

CONTENTS

ACKNOWLEDGMENTS

For my family.

For Shirley Wight Keeney, the most priceless treasure in the collection of the Summit Historical Society. Without her help, patience, friendship, and guidance, this book would not exist.

And for the late Mary Katherine Fitzpatrick, historian, mentor, collector, and friend. This is your book, and we miss you. Wish you were here.

—P.E.M.

INTRODUCTION

In the 100 years since Summit became a city in 1899, countless millions of postcards have been sent in the United States. Today we send them mostly from vacations or as meeting reminders, but in the days before phones, faxes, and e-mail, postcards served as a major means of communication for Americans. Summit was no exception. Here they served as invitations to tea and as birthday, Fourth of July, Easter, and St. Patrick's Day greetings, and they reminded recipients of train arrival times. They were also used as advertisements and thank you notes. "Meet me at the station at 11 or half past," wrote one sender in 1914, while seven years before a visitor to the city asked, "How is Irvington? Summit beats it, doesn't it?" In the summer of 1941 a vacationer wrote that the squash in her host's backyard were growing like crazy, and wanted her friend to know the weather in Summit was hot and humid and she got to have "an auto ride quite often." A few years later a local auto dealership offered on a card "a wonderful deal on a beautiful Chrysler or Plymouth."

The Summit Historical Society's collection of local postcards is extensive, and this fund-raiser book features nearly 200 of them. The first documented curator of the collection was Willis Pott, aided by volunteers who included Baldwin White, Peg Long, and Howard Welsh, among others. Over the years the cards have been donated and have been purchased at estate sales, auctions, book sales, rummage sales, and paper shows. Some were bought by mail through dealers in places from Seattle to Sarasota.

Houses of worship were apparently the best-selling images reproduced over the decades. Nearly a dozen varieties each have been collected of Calvary Episcopal, St. Teresa's, and Central Presbyterian. At the same time, none has ever been located of Fountain Baptist or St. John's Lutheran, and we have never happened across a postcard of Temple Sinai or the estate the congregation now calls home. There are many schools, organizations, buildings, and sites of which we do not have postcard views. Among them are Oak Knoll School, the Fortnightly Clubhouse, the New Jersey Center for Visual Arts, the Reeves-Reed Arboretum, the Red Cross chapter house, the Strand

Theater, the De Bary House, the Municipal Golf Course, the Summit Diner, and the c. 1740s Carter House, Summit's oldest home and our museum and headquarters on Butler Parkway. We also wish we had cards of some of the city's well-known residents over the years, including educator Hamilton W. Mabie, professional baseball player Willie Wilson, architect Joy Wheeler Dow, and Hudson River School artist Worthington Whittredge. Actually, we have only a handful of postcards of people. It is our hope that the publication of this book sends readers up to their attics, into the backs of bureau drawers, and rummaging through long-forgotten scrapbooks. We look forward to expanding our postcard collection in the years to come, and are not ruling out a second volume.

Summit is a community known for its tree-lined streets, excellent schools, varied opportunities for worship, successful downtown, gracious homes, cultural offerings, spirit of volunteerism, and athletic facilities. A glance through the postcards reproduced here is a mini-lesson in the last 100 or so years of Summit's history as a community. Included are hospitals, summer resorts, homes, people, businesses, parks, and schools. Unfortunately, as the city grew over the last century, the production of local postcards declined.

It is a goal of the Summit Historical Society not only to collect maps, memorabilia, costumes, photographs, documents, and books that deal with the community and its people, but also to preserve, display, and share that collection with the public. We are proud of Summit, and after looking at the images highlighted in this book, you will see why.

As the sender of a postcard in 1906 wrote, "Arrived Summit yesterday. Like it exceedingly."

Patricia E. Meola, May 1998
The Summit Historical Society
90 Butler Parkway, P.O. Box 464
Summit, NJ 07902-0464
(908) 277-1747

One

SCHOOLS

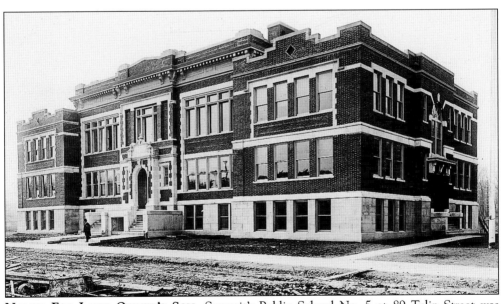

NAMED FOR LAND OWNER'S SON. Summit's Public School No. 5 at 89 Tulip Street was named to honor the late Brayton Larned, son of W.Z. Larned, who donated the land. During construction, many considered the site almost out of town. Brayton School opened in the fall of 1912 with 10 classrooms and 267 pupils, 37 of whom attended kindergarten. The first principal was Helen Cassidy.

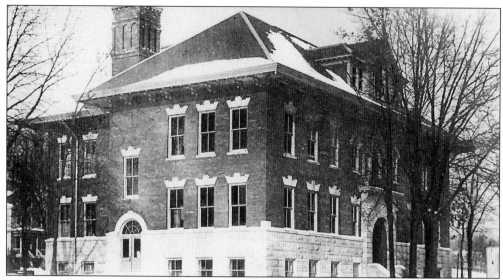

NEW EAST SUMMIT SCHOOL. "Here is where my children go to school," wrote Mrs. Meisel in 1905. Public School No. 2 began its life in 1871 as a two-room building on land given by Benjamin Dean and John Kelly. The New East Summit School was named Roosevelt after a student vote in 1920. It closed in 1979 due to declining enrollment and was redeveloped as residential condominiums.

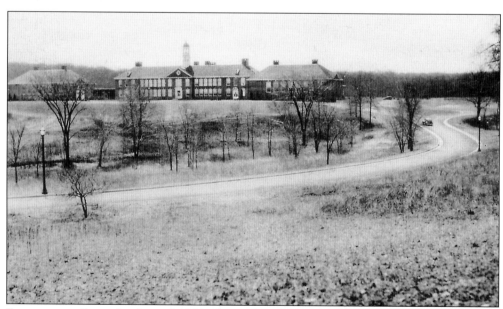

EVENTUALLY SOLD. In the mid-1930s the student body outgrew the combined junior/senior high school on Morris Avenue. Edison Junior High was built in 1938 for $600,000, not including the cost of grading work done by the WPA. By 1945 the school was only 38 percent occupied, and the building and its 38 acres were sold to the Celanese Corporation for $326,000.

THROUGH THE TREES. The Summit Academy's address was 50 Woodland Avenue. The principal, James Heard, was described in a newspaper article in the 1890s as "very energetic and thoroughly live." Mailed from Summit to Hyannisport, Massachusetts, in 1912, the sender of this card signed it M.E.K. and gave the return address as 124 Hobart Avenue.

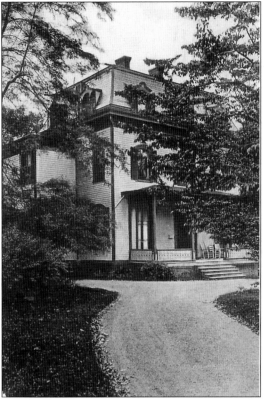

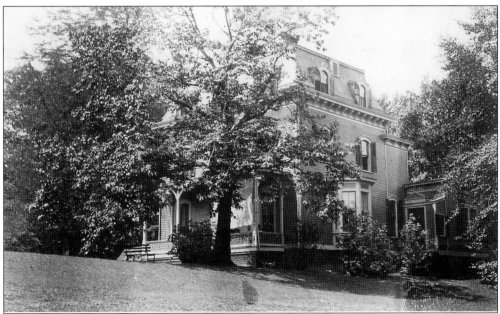

AN "ENGLISH CLASSICAL SCHOOL." Principal James Heard came to town in 1885 to take over declining enrollment at St. John's Hall, a military school. Academy classes were held in a Crescent Avenue home until 1895, when they moved to the building above on Woodland. It was described in an 1899 *Summit Gazette* as an "English Classical school for men and boys."

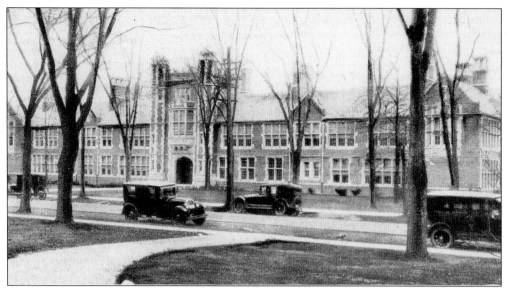

HAVE YOU NOTICED THE GARGOYLES? In 1923 the high school, constructed of Harvard brick, opened on Morris Avenue. Amid the limestone trim above the main entrance are five gargoyles that represent manual training, athletics, dramatics, music, and household arts. Until 1922 the only building on the block had been a home owned by David W. Bonnel, whose family firm sold the plot to the town.

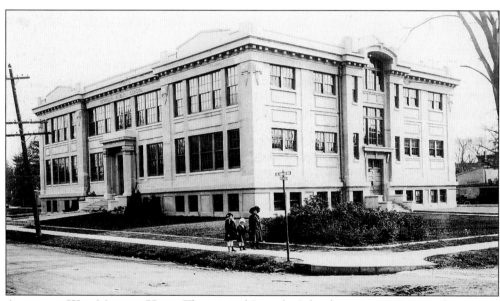

ARMISTICE WAS MARKED HERE. The original Lincoln School went up *c.* 1909, and was razed in 1955. Summit citizens celebrated the November 11, 1918 Armistice there. The mayor distributed honor medals, and special tribute was paid to the families of 15 Summit men who died in World War I. The current Lincoln School on Woodland Avenue was constructed in 1953.

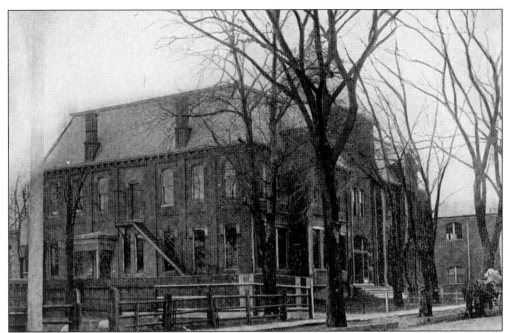

MANY FACELIFTS. Completed in 1878, this building at 512 Springfield Avenue was called Summit Public School. Its first teachers were Thomas Collard and M.E. Tappan, who had 50 students each. By 1920 it became a high school. On the night before mid-terms, the school was damaged by a suspicious fire. The site was restored and remodeled as City Hall in 1946. It remained the municipal headquarters for nearly 50 years.

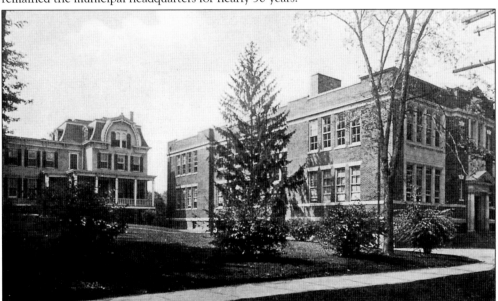

BUILDING MARKS 90TH BIRTHDAY. St. Teresa's School first held classes in a rented building in about 1870, when the parish was still a mission of St. Vincent's in Madison. In 1902 the building at left housed the school until the one at right was completed in 1909. The older building was moved to serve as the convent and is now faced with brick. The roof line and gable are still visible.

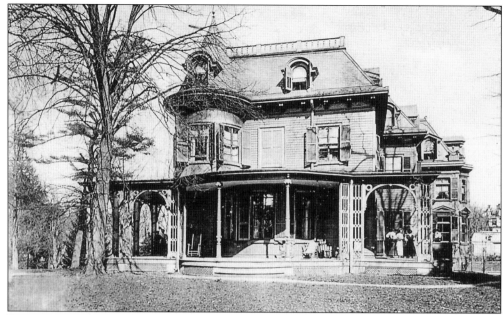

EQUAL EDUCATION. Labeled "Kent Place School for Young Ladies," this card was sent in 1911. Before the school existed, this structure was the Moller Mansion. It was purchased by William De Forest in 1874. Kent Place School was founded in 1894 by a group of men who said they believed their daughters deserved the quality of education available to their sons.

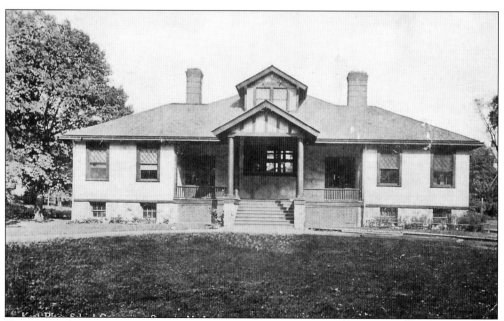

KENT PLACE GYMNASIUM. This card mailed from Summit on September 9, 1912, depicts the Kent Place School Gymnasium. Ella, the sender, wrote, "Dear Aunt and all—Have been so busy sewing had not time to write. I was down to N.Y. . . . and had a fine time."

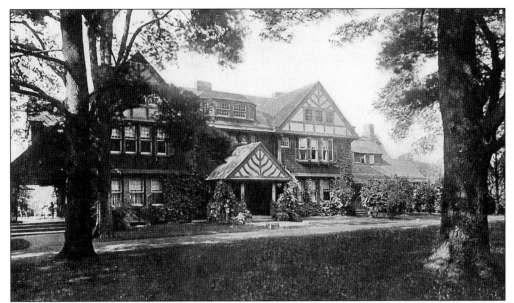

FROM A HOME TO A SCHOOL AND BACK. James T. and A. Louise Truslow bought 24 acres of land in 1887 and began building a home at 14 Bedford Road the following year. In 1907 Carlton Academy occupied the site. In 1924 the name changed to Oratory School, and when a new building went up in 1960 on Beverly Road, the Truslow home became the priests' residence.

AWAITING THE CHILDREN. For many years, parents of Summit preschoolers have had a variety of education options. Among them is the nursery school at Central Presbyterian Church, whose nursery room is depicted in this undated photo postcard.

PRESIDENT OF HER CLASS. The president of the six-member Summit High School Class of 1899 was Lillian Erma Kelley, who also delivered the valedictory address. Her fellow graduates were Edna May Burling, Theodore Edward Hazell, Clara Isabella Wulff, Ledlie Dominick Moore, and Wilberforce Ogden. The school principal was J.K. Lathrop, and the president of the school board was J. Frederick Chamberlin.

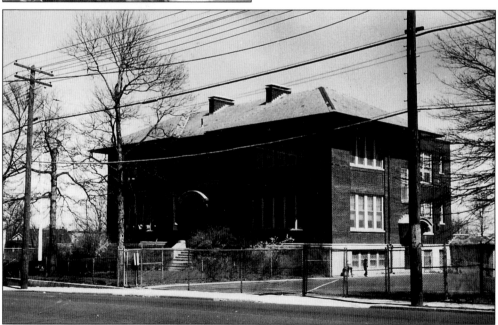

WASHINGTON SCHOOL. In 1910, elementary schoolchildren in Summit attended Lincoln, Roosevelt, and what was called a "portable building" in the western end of town. In 1912 Brayton opened, as did Washington School on Morris Avenue. Early additions at Washington were constructed in 1922 and 1929, and the main door no longer faces Morris Avenue.

Two

DOWNTOWN

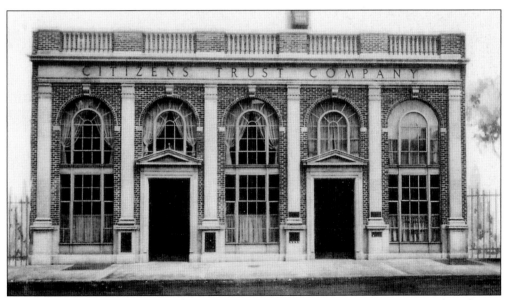

YOU COULD BANK ON IT. Founded in 1923, the Citizens Trust Company moved to this 30 Maple Street address a year later. James D. Hood was the first president. According to bank literature, the institution was founded by men "who had witnessed the progressive growth and development of Summit" and "envisioned a still larger Summit in the future."

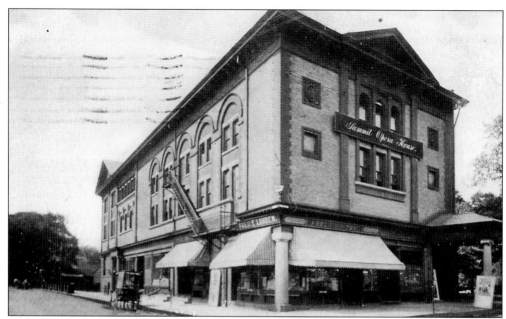

THE SUMMIT OPERA HOUSE. Built in 1894 by Joel G. Van Cise, the building at 2 Kent Place Boulevard began its life as a home for the local Women's Christian Temperance Union. This 1911 view shows Fred E. Lunden's store on the ground floor.

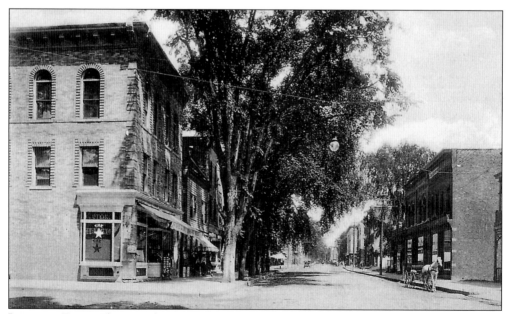

LOOKING EAST. This was the view in 1909 looking east from the corner of Springfield and Woodland Avenues. The view was mailed to Mrs. G.R. Rau on Crawford Street, Newark. Its message reads, "Dear Etta—No, Mamie did not buy that present for Amelia. She said she did not see any nice ones. Lydia."

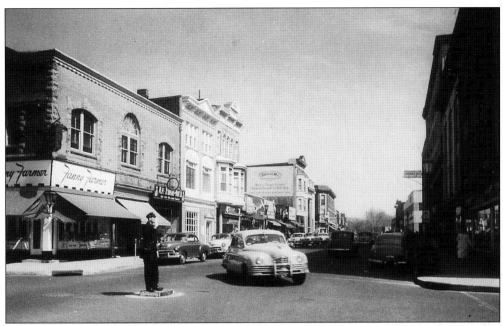

DOWNTOWN TRAFFIC CONTROL. The building at left housed a Fanny Farmer candy store from 1940 until the 1990s, and was at one time the YMCA, constructed in 1893. Prior to the installation of downtown traffic lights, a police officer stood in the intersection on a small platform and used his hands and a whistle to direct drivers and pedestrians.

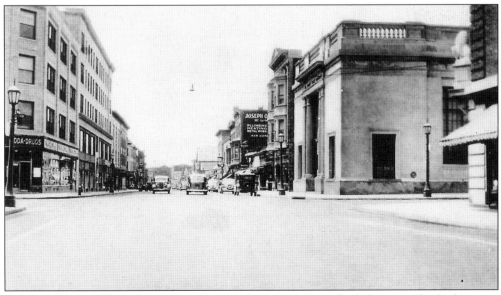

A MAIN DRAG. When this card was postmarked in 1941, traffic lights on poles had not yet been installed at the intersection of Springfield Avenue and Beechwood Road. The bank on the right looks much the same as it did nearly 60 years ago, as do the upper stories of the Bassett Building at left. At the upper right are the lions over the door of the Melrose Building.

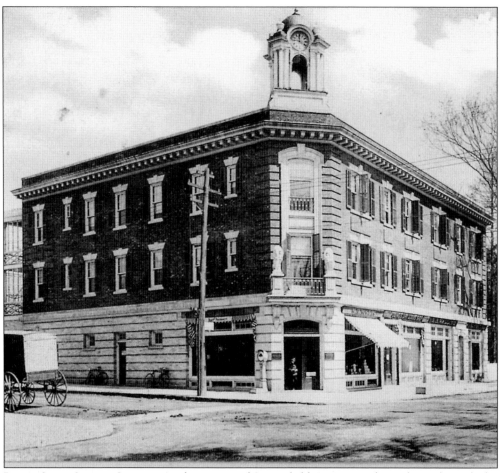

LIONS STILL STAND GUARD. At the corner of Springfield Avenue and Beechwood Road, the two lions that stood guard over the door in 1909 remain today. The Melrose Building opened on October 19, 1907. Until it was removed in 1937, the city paid $100 a year to light and maintain a clock tower that crowned the building.

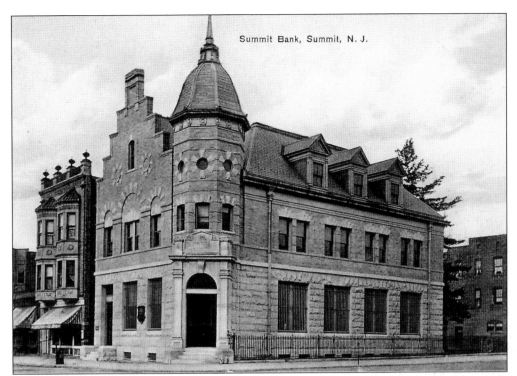

Summit Bank, Summit, N. J.

A DOWNTOWN LANDMARK. Established in 1891, the Summit Bank was the town's first such institution. In 1898, a building of Ohio sandstone was constructed at the northwest corner of Beechwood Road and Springfield Avenue. Its corner entrance boasted the only revolving door in town. The site was remodeled in 1928–30.

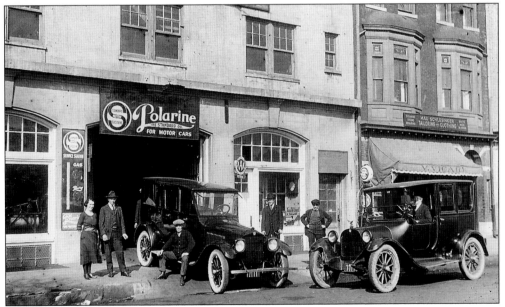

"THE BOMB SHELTER." The firm of James Geddis & Sons operated an auto livery and garage in a concrete building at 31 Union Place built in 1906. The building was called "The Bomb Shelter" because of its sturdy construction.

GRASSY ISLAND. The Summit Garage and a feed store on Union Place have long since been replaced, but the grassy island and the railing that borders the train station remain. At the center of this view is the stone horse trough that stood for years and offered refreshment to transportation providers before most residents owned automobiles.

WAS IT TIME TO COME HOME? In the summer of 1910, Mother wrote to Helen B. Hine, who was in Belgrade, Maine, the following message: "Edward wants to know if it isn't time for Helen to come home, he thinks she has been gone a long time." At the center of this card is Old Town Hall, 71 Summit Avenue, with its bell tower.

22

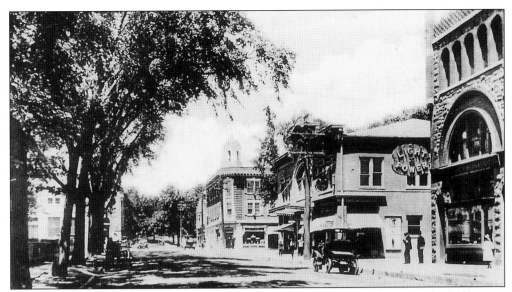

AN EARLY MOVIE VENUE. Between the Light & Power sign and the Melrose Building was the Lyric Theater at 23 Beechwood Road. It opened in 1914 with ushers and doormen in full uniform, and was destroyed in an early-morning blaze on May 25, 1951. The owners had planned to close for renovations two days later.

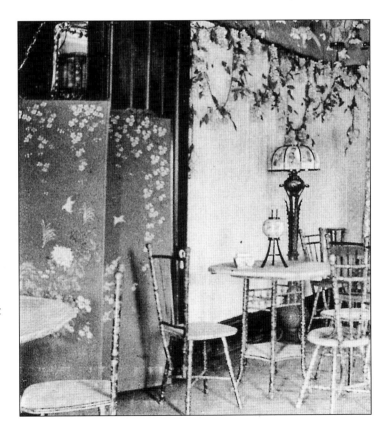

TEA FOR TWO. A Japanese motif was the order of the day earlier in the century at a tearoom within the Manley home at 550 Springfield Avenue. The room was created by Mary M. Rosé, who hired Kishiro Kanzaki as the caterer.

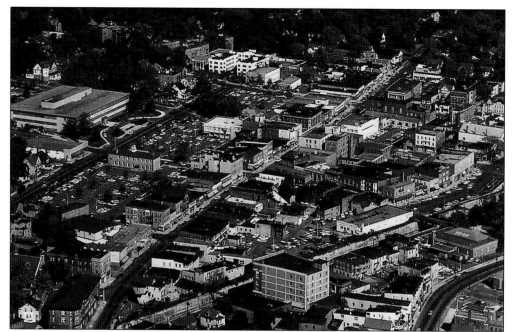

FROM THE AIR. Using the Summit Opera House in the lower left as a landmark, one can note changes in the cityscape since this photo was taken in the early 1960s. Trees grow where the bank drive-in stands, there is no tiered parking garage, and homes, businesses, and a warehouse were not yet razed to make room for senior citizen housing at 12 Chestnut.

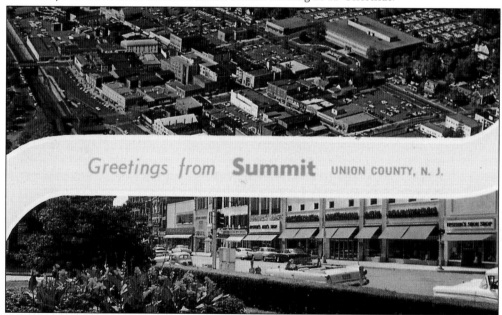

GREETINGS FROM SUMMIT. Even though the views on this card are modern compared to others in this volume, there are still drastic downtown changes that have occurred in recent decades. Using the multi-storied Kemper Insurance in the upper right as a landmark, notice the absences of the Summit Medical Group, the office building at 47 Maple Street, and the tiered parking garage behind it, for starters.

24

Three

THE RAILROAD

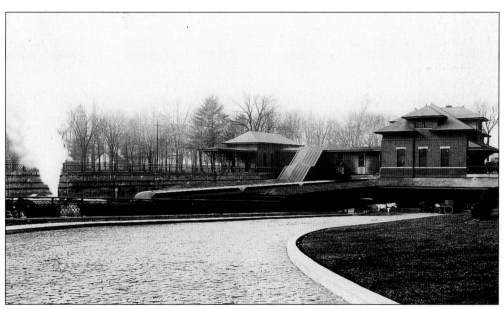

ALL ABOARD. In the 1830s, the original route from Newark to Morristown had trains bypass Summit. Local sawmill owner Jonathan Crane Bonnel was a stakeholder in the Morris & Essex Railroad Company and offered a free right-of-way if trains would journey over what was considered "The Summit of the Short Hills." By 1900 Summit residents were commuting to New York, and in 1904–05 the present rail station was built.

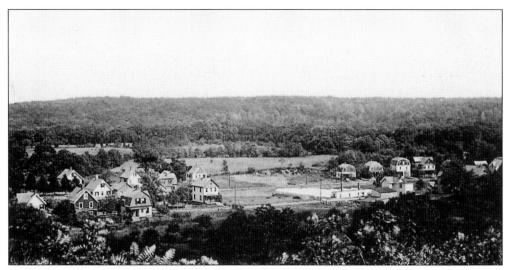

BEFORE THE RAILROAD. With nothing but trees in the distance, this card illustrates the view from Overlook Mountain prior to the presence of railroad tracks.

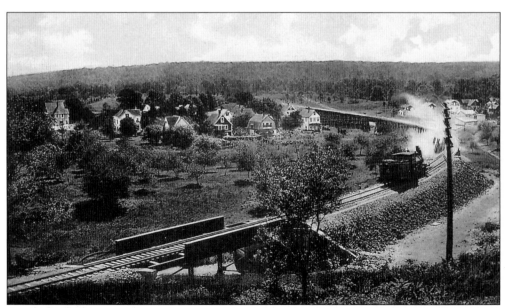

AFTER THE RAILROAD. Just a few years after the above card was published, this updated view was created. What appeared to be rows of greenhouses in the earlier depiction were apparently razed to make way for elevated tracks.

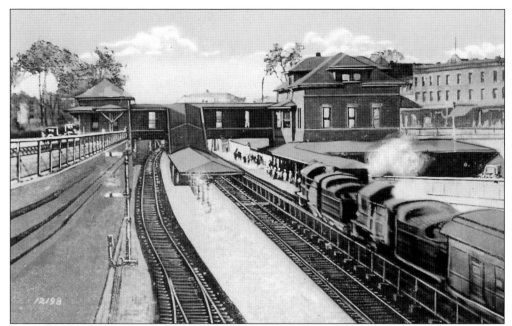

NEXT STOP SUMMIT. From 1837 to 1904 the train tracks through town were at street level. In 1904 the rails of the DL&W (Delaware, Lackawanna & Western) Railroad were depressed. The so-called "mile-long cut" runs approximately from Overlook Road to High Street. A new depot was constructed on Union Place in 1904–05.

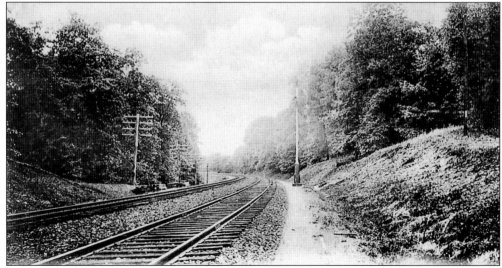

A CURVE ALONG THE LACKAWANNA. Train transportation has long been of great importance to the citizens of Summit. This view was mailed from the city to Irvington in 1912.

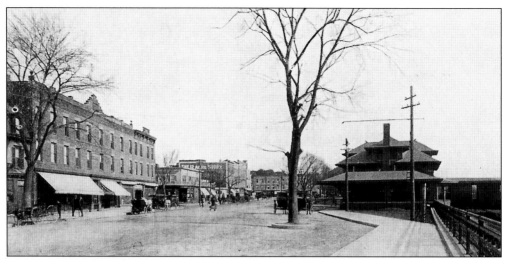

STATION SQUARE. Horse-drawn carriages stand on Union Place after the turn of the century awaiting commuters where today taxis, station wagons, and suburban utility vehicles line up. It is interesting to note that the card was labeled "Station Square, Summit" and that the fence at the far right remains.

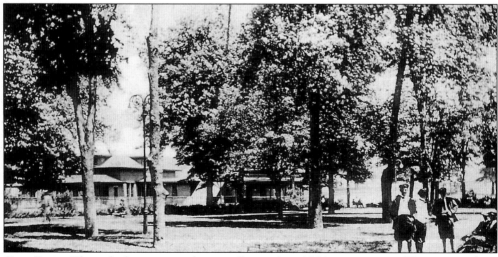

CITY PARK. Through the trees can be seen Summit's *c.* 1904 train station. This view is from Broad Street looking towards Summit Avenue.

Four

PUBLIC BUILDINGS

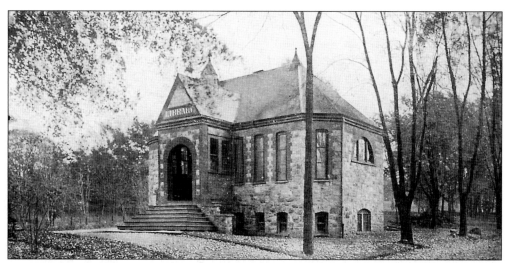

NOT FREE OR PUBLIC. Summit's first library was founded more than 100 years ago, but it was not free, nor was it public. It opened its doors in 1891 with Louise Le Huray as librarian. In 1911, the free public library opened on Maple Street, and the building at the corner of Tulip and Springfield was leased to the newly formed Summit Dramatic Club, now the Summit Playhouse Association.

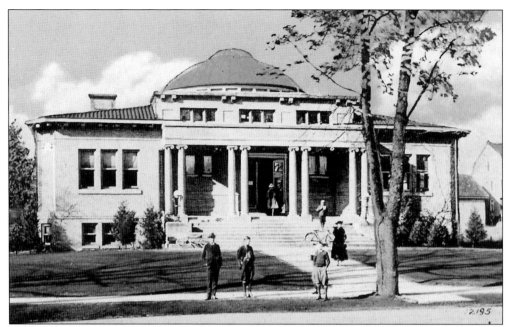

ON DONATED LAND. Dedicated in 1911, the library went up on land donated by the Bonnel family's Summit Home Land Company. The architect was Earl Harvey Lyall, and Andrew Carnegie contributed $21,000 towards the project. It was replaced in 1964, but for a time the two adjacent buildings existed, and cartons of books were slid down a chute from one to the other before the earlier structure was razed.

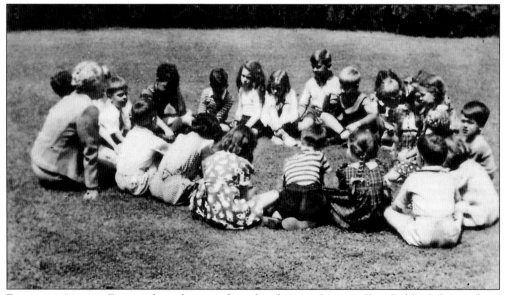

READING ALOUD. For nearly as long as there has been a Summit Free Public Library, there have been story hours. The 21 children in this undated photo that was converted to a postcard were enjoying tales told outdoors.

GIANT SHADE TREES. Looking down Maple Street towards town from Morris Avenue, one can see the 1911 Carnegie Library at 75 Maple Street. At the far end of the block is the red-bricked YMCA, constructed in 1912. A pool annex was added in 1958.

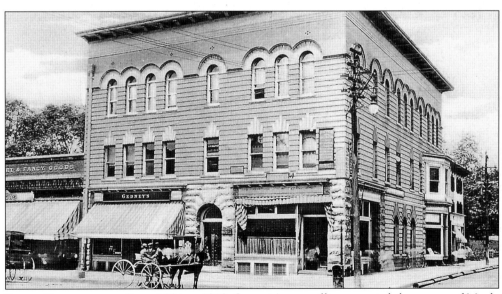

EARLY POSTMASTERS. From 1894 to 1910, Summit's post office occupied the corner of Maple Street and Springfield Avenue. Early city postmasters included William Littell, Daniel Noe, James Rice, Theodore Littell, William B. Coggeshall, and Bridget Lane.

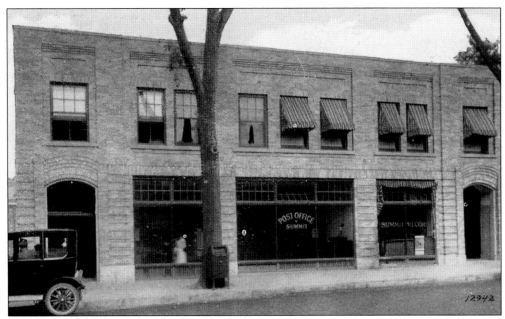

A STOREFRONT LOCATION. From 1910 to 1920, Summit's post office was located in the Record Building at 37–39 Maple Street. From 1920 until a new building was completed at 61 Maple in 1936, letters and packages went in and out of 20 Beechwood Road, pictured, opposite Bank Street. The *Summit Record* was the town's Democratic paper. Founded in 1883 by Newton W. Woodruff, it merged with the *Summit Herald* in 1924.

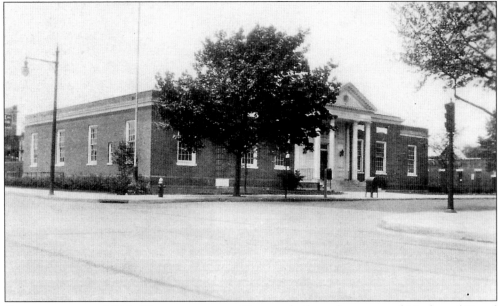

CONSTRUCTED IN 1936. The current post office was built at the corner of Maple and Broad Streets in 1936. By then local residents had been getting mail for nearly 100 years. The federal government established a post office at what was known as the Summit of the Short Hills in 1843.

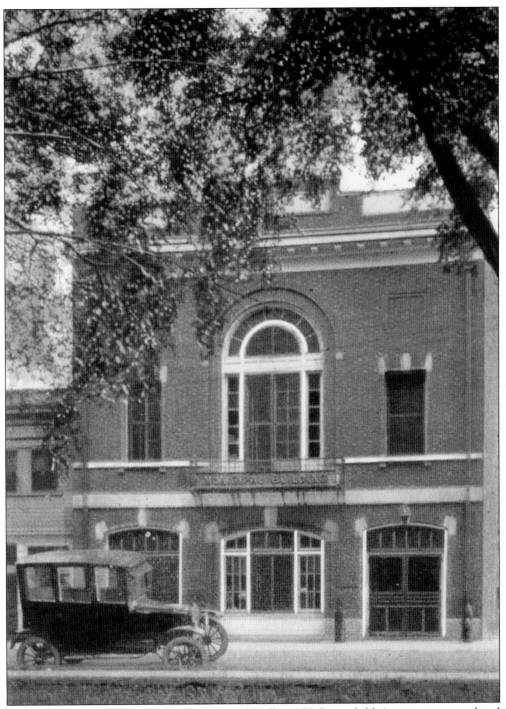

BOUGHT AT A FORECLOSURE SALE. Colonial Hall at 350 Springfield Avenue was completed in 1906. On the ground level was a garage for the storage and care of cars, and upstairs, with a capacity of 500, dances and other entertainment events were hosted. By 1909 the owner faced financial difficulties, and the City bought the site at a foreclosure sale for $18,500 and converted it into a municipal building.

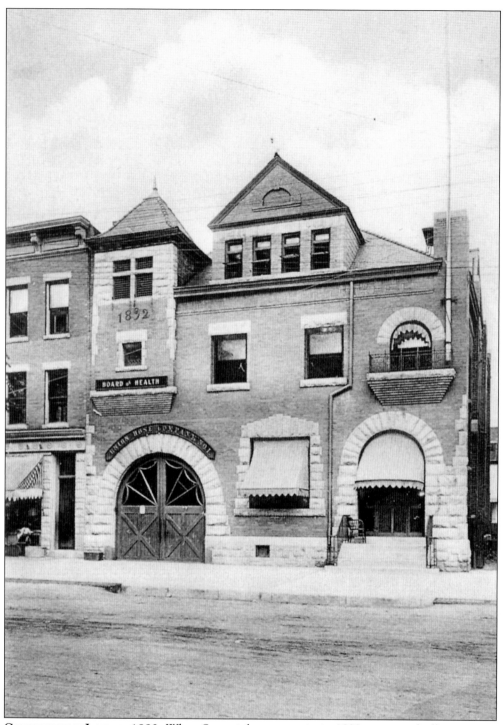

CORNERSTONE LAID IN 1892. When Summit became a city in 1899, municipal offices were at 71 Summit Avenue, where the cornerstone was laid in 1892. John N. Cady was the architect. Behind the chimney is the steel tower erected in 1896 to hold a 2,500-pound bell that now hangs outside the current firehouse on Broad Street.

Five

HOMES AND APARTMENTS

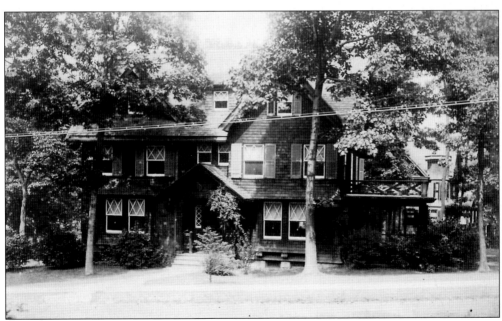

A DIFFERENT LOOK. This undated card of the home at 49 Oak Ridge Avenue shows it with dark shingles and light-colored shutters. The house still stands at the corner of Elm Street and Oak Ridge.

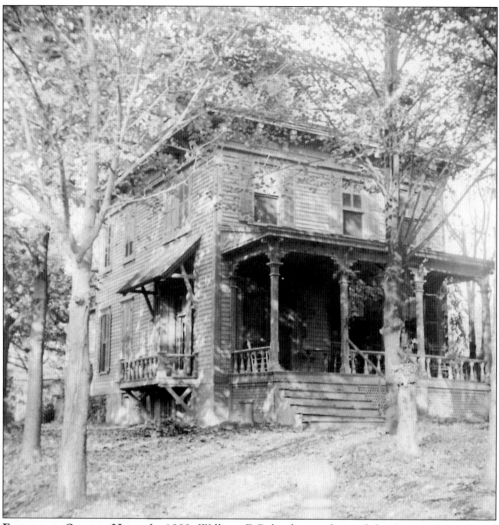

EDITORIAL OFFICES HERE. In 1889, William F. Byland was editor of the *Summit Gazette* and offices were at 285 Springfield Avenue. The home stood between Waldron and De Bary, on that side of the street. It has been replaced by a modern house. Among Mr. Byland's coworkers was his mother. The *Gazette* was first published in 1887 and lasted six years.

A STATELY SUMMIT AVENUE PRESENCE. The De Forest Court Apartments are believed to be the city's oldest such complex, built by the Aetna company in about 1922. The Summit Historical Society archives contain no details about the site, a U-shaped trio of buildings on Summit Avenue at the end of De Forest.

NAMESAKE APARTMENTS. Hudson River School painter Worthington Whittredge was born in 1820 in Ohio. In about 1860 he lived in New York City and in 1879–80 built a home at 166 Summit Avenue. Mr. Whittredge lived in Summit until 1910, and the Worthington Court and Whittredge Gardens Apartments were constructed on land he had owned.

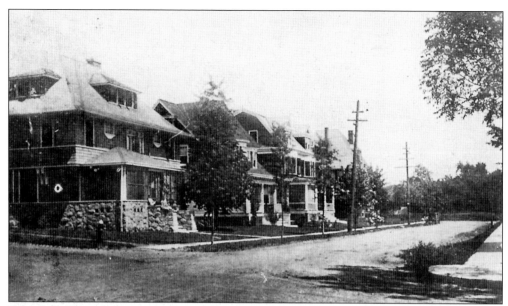

BEFORE IT BECAME BUSINESSES. In 1909, a row of stone and shingle homes occupied a corner of De Forest Avenue and Beechwood Road. The view was mailed from Summit to Miss E.E. McCulloch on Chestnut Street in Albany, New York, by someone who signed her name Emma M.S. These are the houses faced when one exits the drive-through bank across the street.

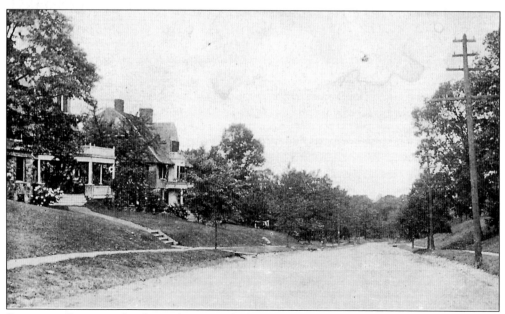

SERVED A PURPOSE. In the early 1900s, before phones, faxes, and modems became major methods of communication, those wishing to stay in touch often relied on the mail. The sender of this card, who signed with the initials J.D., wrote, "Are you going to the party Friday night? Let me know." The recipient was Arthur Kelley, 32 Park Avenue.

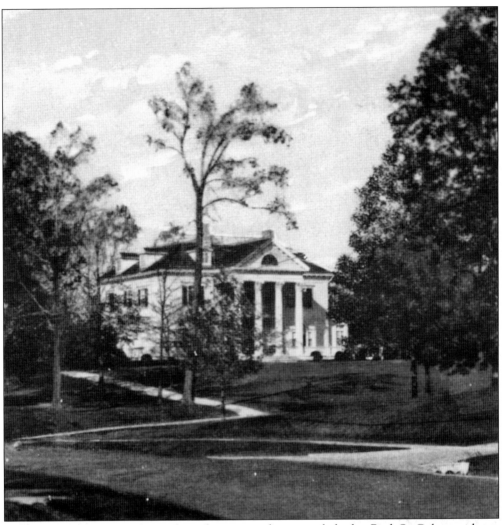

HIGH ON A HILL. In 1911, when this postcard was mailed, the Bird S. Coler residence commanded a stately presence from a hill where Ridge Road meets Summit Avenue. The home is no longer standing.

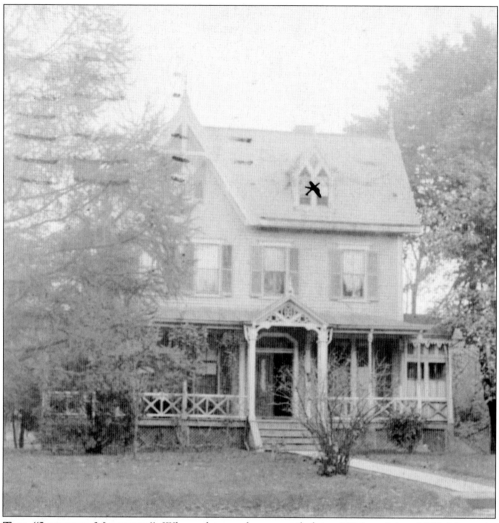

THE "JOHNSON MANSION." When this card was mailed in 1906 to Mrs. M.T. Moon in Morrisville, Pennsylvania, 256 Springfield Avenue was a boarding house run by Anna Johnson. The message penned reads, "This is the Johnson Mansion—the Dickens household as Miss White says. The room marked is the one Miss Rosen and I occupied—rather she occupied and I paid for."

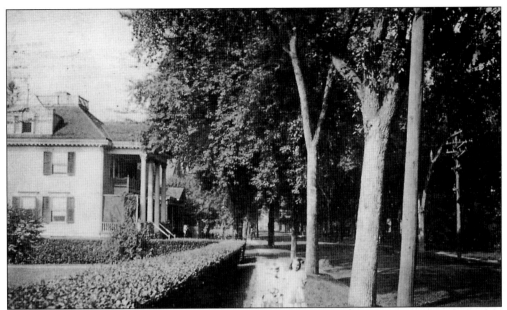

CORINTHIAN COLUMNS. "We are enjoying the country here," wrote the sender in 1911. This view of Springfield Avenue faces west, with No. 300 at left. The building was constructed *c.* 1890 with a pedimented gabled entrance portico supported by Corinthian columns, and its owners from 1909 to 1912 were Sam and Becke Katz. According to Daniel Woodside, who responded to a 1998 photo query in the *Summit Herald*, Mr. Broadhead, a teacher at Summit High in the 1940s, lived in the house at one time.

STILL STANDING. When this Colonial Revival home was built *c.* 1920, its residents were members of the William F. McChesney family. The house at 34 Hawthorne Place features an arched entrance, and gable ends are topped with Palladian windows.

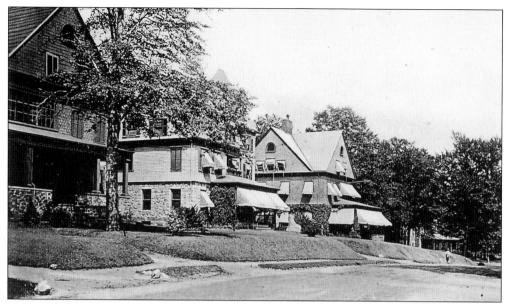

"Will Not Have Time." Although the Summit Avenue end of Euclid consists of modern condominium buildings, large homes remain near the intersection at Beechwood Road. This card was mailed from Summit on April 27, 1909, and the sender apologized for not having more time to write, demonstrating how the cards were relied upon to send everyday messages that in the 1990s are likely to be delivered by phone or computer.

Another View. A slightly different view of Euclid Avenue is presented on this card, mailed in 1911 from Summit to Alice Meares at Rutland High School in Dublin, Ireland. Her friend Esther wanted her to know the "house marked X is us."

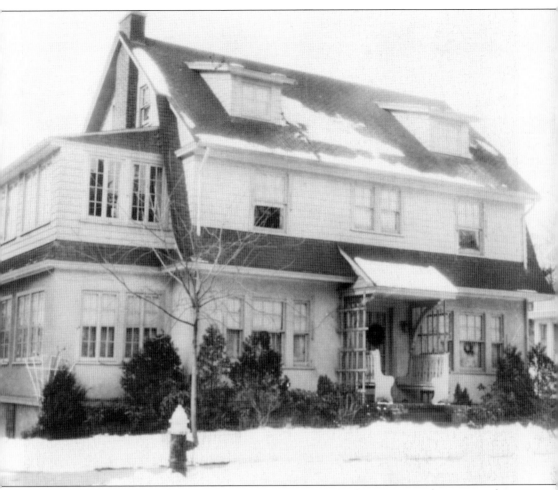

FIRE DID DAMAGE. A query in the *Independent Press* about this house garnered a response from the owner of 20 De Bary Place, Mary Dickey, on behalf of her 11-year-old daughter, Beth. In November 1988, the house suffered a fire that destroyed the interior and burned through the roof. "At that point," said Ms. Dickey, "we had just purchased the house and could have gotten out of our contract. There was something about the place, though, that made us hang on, and in Jan. 1989 we began extensive remodeling."

CARD SENT TO LIZZIE MORAN. This photo card was mailed from Summit to Summit in 1906, so historical society volunteers feel safe in assuming the home was within the city. The sender signed her name Jennie and the recipient was Lizzie Moran, 77 Summit Avenue. The parents on the front porch appear with two girls and three boys. Any help in identifying the house would be appreciated.

A Doctor in the House. From 1922 until he died in 1959, Dr. Cadwell B. Keeney lived at this home at 137 Summit Avenue. It stood across from where Parmley Place begins, and was razed in 1978 and replaced by medical offices.

A Garden Tended by the Family. The Keeney home on Summit Avenue had seven bedrooms and three baths. Longtime Summit Historical Society volunteer Shirley Wight Keeney grew up on Waldron Avenue and married Dr. Keeney's son. She remembers the family's large garden and raspberry bushes that grew there. Dr. Keeney's medical offices were on the left side with the family's home on the right.

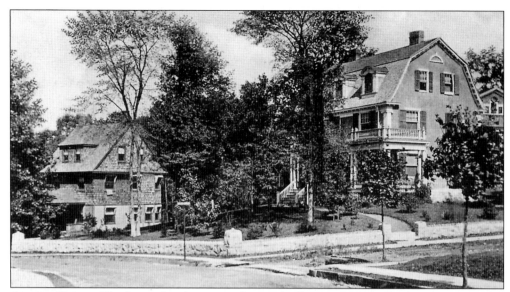

AT THE CURVE. The home that houses professional offices at 55 Woodland Avenue, at right, stands across from the present Lincoln School, at the intersection of Hawthorne Place. This card was mailed to Newark from Gillette in 1911.

ACROSS THE HUDSON. Someone named Dorothy mailed this card with a birthday greeting to Margaret Ogden on West 104th Street, New York. The house at 144 Summit Avenue is gone, but through records at the Summit Historical Society, it is possible to trace its ownership. In a 1900 atlas, the site belonged to D.W. Day and son, and a 1909 listing shows Charles R. Bard as owner, as does a 1911 phone book. In the 1932 and 1934 directories, R.D. Franklin owned the house, and Louise R. Bard is in a 1936 book as the owner.

CONSIDERED A CLASSIC. The home at the corner of Norwood and De Forest Avenues was built in the 1890s for John and Ida C. Brewer. It was bought in May 1908 by Edwin Moister, who turned it over in 1910 to his son, Dr. Roger W. Moister. The house with its corner turret is considered a Classical Queen Anne and was originally sided with split wood shingles. It has been converted to apartments and has yellow siding.

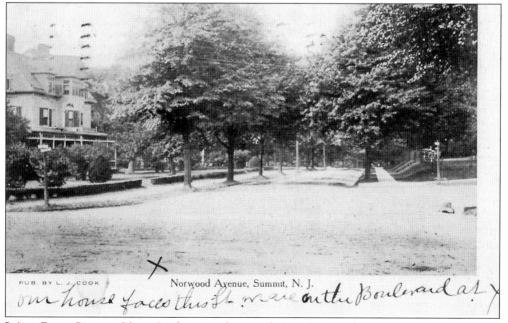

IT'S A BUSY CORNER NOW. Looking north towards Lorraine Road, one can see how Norwood Avenue appeared in 1910. The house at the left has been replaced by a Kent Place School athletic field. The sender of this card wrote at the bottom, "Our house faces this st. We are on The Boulevard at X."

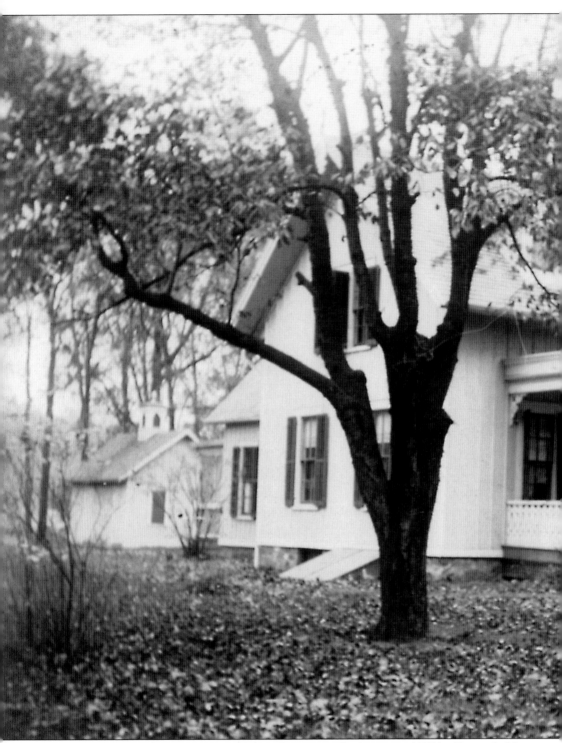

LARGE COTTAGE. This cottage at 31 Hobart Avenue was built prior to 1872 by George LeHuray, a banker in New York. This photo postcard was perhaps sent by his wife, Louisa, to Miss Annie Preston in Hamilton, Massachusetts, in 1906. On it she wrote, "Do you think this is 'such a cute

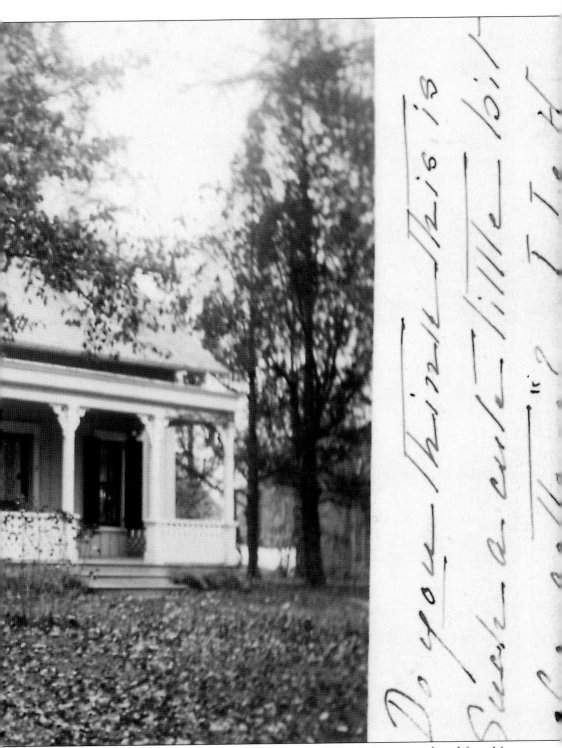

little bit of cottage'? L. LeH." Records show that in 1865 Mrs. LeHuray purchased from Mary Vanderpoel Hayes a large piece of land south of Springfield Avenue between Hobart and the Edgewood Road area. She called it "Mount Prospect" or "Prospect Hill Park."

ROSE HOUSE. George LeHuray, a banker, built 14 Franklin Place for his mother and two unmarried sisters. It was called Rose House. He also constructed the homes at 4 and 8 Franklin Place and built Kettle Drum, at 49 Hobart Avenue, in about 1861 for his son. It remains Summit's only surviving example of Italian Villa style. The elder Mr. LeHuray in 1859 lived in a house on Springfield Avenue that was later moved to 9 Irving Place.

ON PROSPECT HILL. A woman named Lucy sent this view of Prospect Hill Avenue to Florence Figg in Richmond in April 1940. "I have been here with Austin & Helen for a little over a week," she wrote, "and expect to be here until May 18. They are going to Florida then and are stopping by home . . . will take me back with them. The children are both darling."

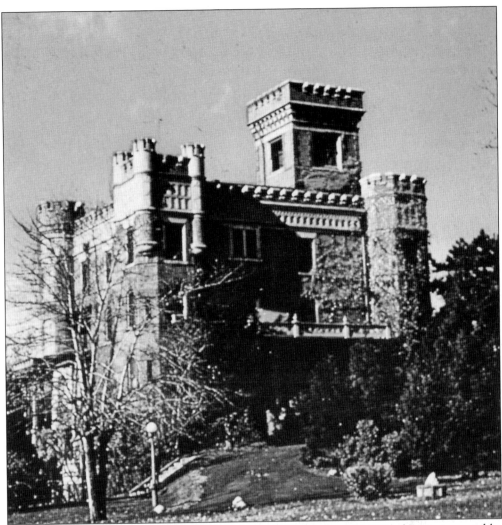

A BRICK FORTRESS. Vanderpoel Castle, built in 1885, stood until 1969, when it was razed by the New Jersey Highway Department to create the JFK Parkway, Route 24, and River Road interchange. The red-brick castle had a round-the-clock guard who marched 17 miles on each shift. Ambrose E. Vanderpoel (1875–1940) was the only child in his family to live to survive infancy. He studied law, but the lifelong bachelor retired early to manage the family estate and write books that included a history of neighboring Chatham.

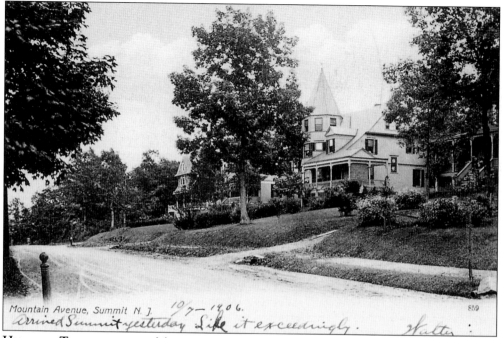

Mountain Avenue, Summit N. J. *10/7—1906.*

arrived Summit yesterday Like it exceedingly. Walter:

859

HISTORIC THOROUGHFARE. Mountain Avenue is a well-traveled road that runs nearly from one end of town to the other. But its selection of Victorian and other period homes helps the street maintain its residential feel. This image of the avenue was mailed from Summit to Boston in 1906 by a gentleman named Walter, whose message was, "Arrived Summit yesterday. Like it exceedingly."

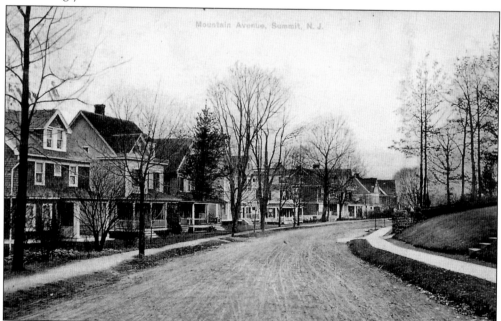

Mountain Avenue, Summit, N. J.

AN INDEPENDENCE DAY GREETING. Mailed on July 3, 1913, to Marie Voegtlen of Mountain Avenue, this card features a view of the street on which she lived. "I couldn't find a Fourth of July card," wrote someone named Reuben, "so am sending this instead."

A Puzzle Solved. Historical society volunteers were stumped by this view until former Canoe Brook Parkway resident Ann Mackin Fairchild set the record straight. The scene is confusing because the house at the far left came down when the highway was built. Today the house second from left is the first home on the street.

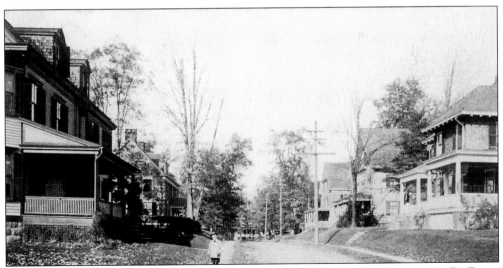

Hillside at De Forest. Hillside Avenue is a block long and runs from Crescent to De Forest Avenues near the downtown district. This card was mailed from Summit to a vacationer at Culvers Lake, Branchville, in 1906.

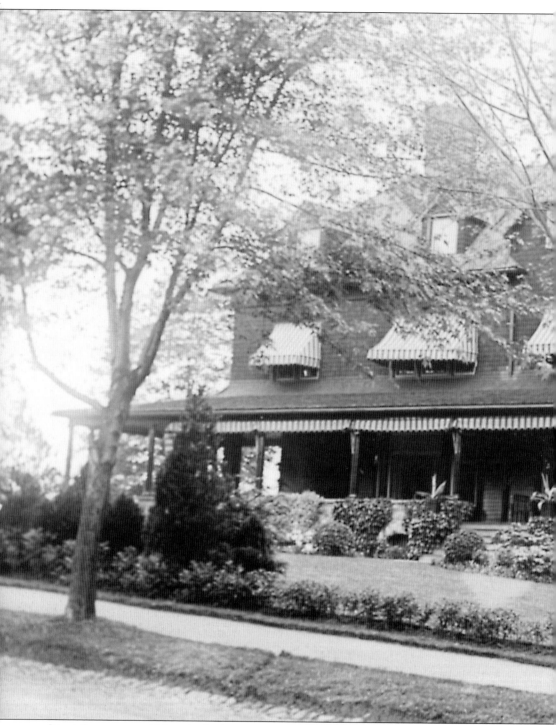

STILL STANDING. Although the house is missing its elaborate landscaping and candy-striped awnings, 77 Prospect Street is still recognizable as the home built by Walter Dean Briggs *c.* 1896. Mr. Briggs worked in New York for Wanskuck Dry Goods. He was known as an avid horseman who maintained elaborate stables until 1913, when the advent of automobiles and

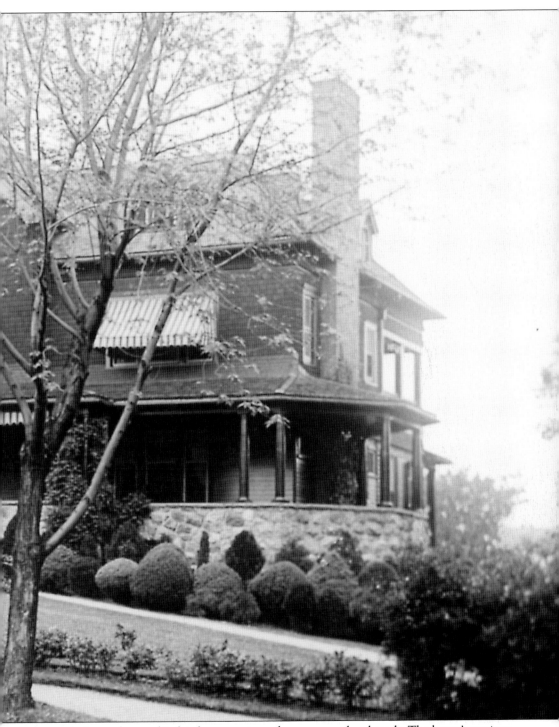

their popularity made travel in his fancy carriages dangerous on local roads. The home's carriage house was converted to a residence at 30 Blackburn Road, and next to it at No. 24 is "The Paddock," built by Mr. Briggs for his daughter Louise, Mrs. Norman Lee Swartout. It was given to her as a wedding present and named because it occupies an area where horses had grazed.

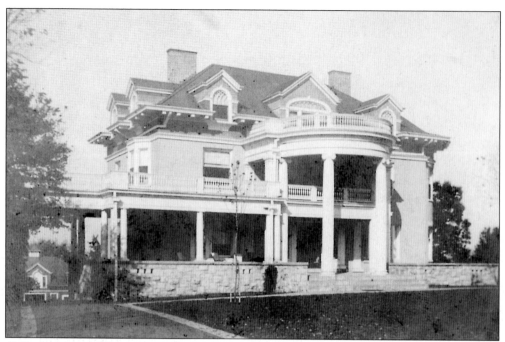

A COMMANDING PRESENCE. Still staking its claim to a large plot of land on Beekman Road is the home owned at the turn of the century by Joseph H. Shafer, a jewelry manufacturer in Newark. The home boasted a wine cellar, maids' quarters, and a tennis court.

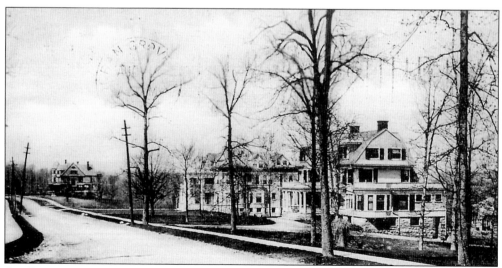

ON BEEKMAN ROAD. The trees have grown and modern houses have been added to the landscape, but little has changed to alter the two homes in the foreground of this 1905 view of Beekman Road. The center house, with its columned entrance, was the J.S. Shafer home.

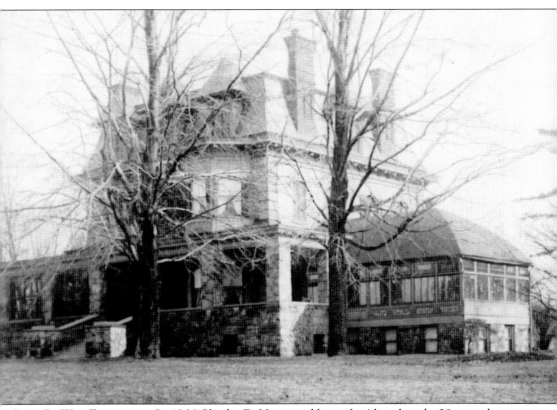

ONCE IT WAS FARMLAND. In 1866 Charles DuVivier and his wife, Alice, bought 28 acres that were the north end of a farm. They continued to purchase adjacent plots, and in the 1870s built Nuthurst at 65 Norwood Avenue. When the site was sold in 1927, most of it became the property of the Viking Realty Company, which razed the house and opened Sherman Park (Sherman Avenue and Lorraine Road) in 1932. Nuthurst's carriage house became 13 Lorraine.

TURN OF THE CENTURY. This undated postcard shows a snowy view of 230 Springfield Avenue at the beginning of the U-shaped Edgewood Road. Architectural historians have termed the *c.* 1900 home late Victorian Eclectic. When a photo query on the house appeared in the *Summit Herald* in 1998, among the respondents were homeowners Roy and Evelyn Tartaglia.

WITH VIEWS OF NEW YORK. Mrs. George E. Smith of Kansas City, Missouri, was the recipient of this card in 1907. It features a view of Edgewood looking towards Springfield Avenue. To the right would be the Fortnightly Club's headquarters, Twin Maples. The house in the distance is 230 Springfield Avenue. (See postcard at left.) Newer homes on the eastern leg of Edgewood are set below street level and some have spectacular views of the Manhattan skyline.

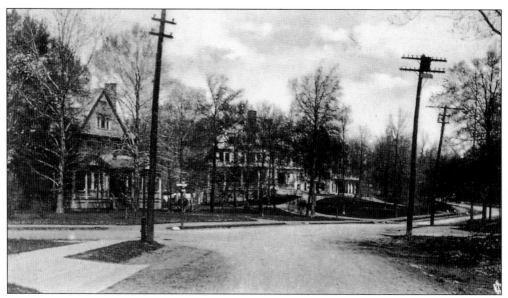

A POPULAR VACATION SPOT. Bishop John Henry Hobart of Trinity Church in New York may have been the Summit area's first summer retreat visitor. In 1808 he built a vacation house in Short Hills, where Hobart Avenue meets Route 24. The estate included adjacent land in Summit. This view shows a selection of fine homes on the bishop's namesake avenue.

SPIRIT OF PROGRESS. A horse-drawn carriage heads towards the horizon in this nearly 100-year-old illustration of the Hobart/Whittredge intersection. In the *Summit Record* in 1892, a story said the "spirit of progress had been displayed to a wonderful extent" in new homes on Hobart.

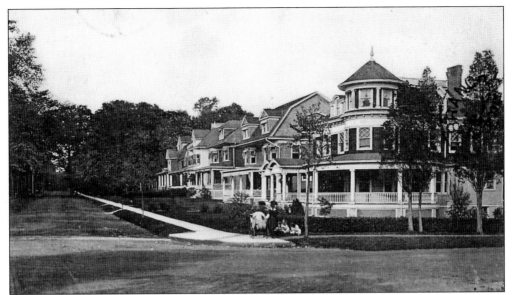

A HUNTER'S PARADISE. The majority of the land on Hobart Avenue between Springfield Avenue and Route 24 was considered prime hunting country at one time. It was not developed until the late 1880s. In 1892 the *Summit Record* reported Hobart had experienced a "remarkable transformation over the past three years."

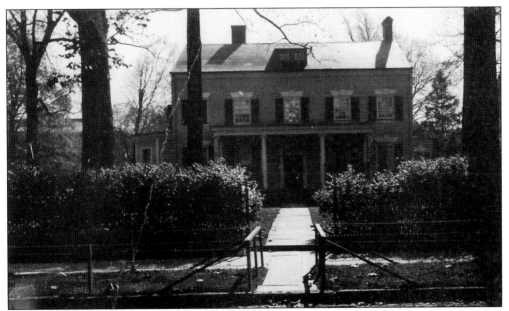

DEAN'S HOUSE. This black-and-white photo postcard has been in the Summit Historical Society's collection for years, but no background information is known. In the bottom left are the words "Dean's House." Dean who, or the dean of what? At left beyond trees is the large roofline of a building, and at the far right is what appears to be a church steeple. At one point the Dean family was one of Summit's most well known, and there was a period when East Summit was known as Deantown.

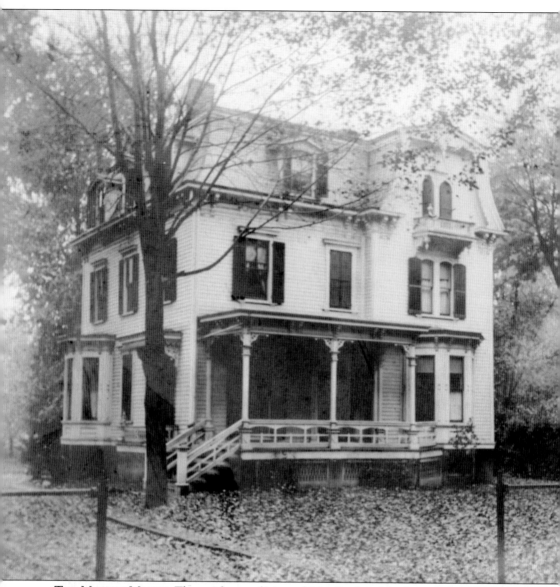

THE MANLEY MANSE. The residence of Mr. and Mrs. Reuben Manley stood at 554 Springfield Avenue at the corner of New England. Mr. Manley was a lawyer in New York who published three novels. The *Summit Herald* in 1924 carried a three-part series authored by him in which he wrote of what Summit was like in 1859. It was said Mr. Manley's greatest pleasures were reading, writing, travel, and the companionship of his family.

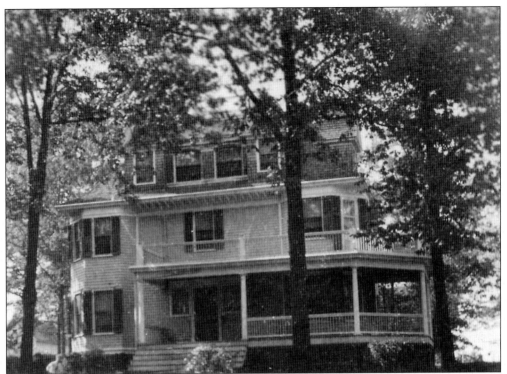

LITTLE SHERLOCK. This card sat in a file labeled with a question mark for years until its publication in the *Summit Herald* in 1998 prompted a call from Sally H. Bockus. The little boy in the bottom left was her father, Ernest S. Hickok, identified in pen as "Sherlock," the middle name she said he detested. Mrs. Bockus said her father (1902–1992) was born and raised in Summit and this image depicts the *c.* 1895 Hickok home at 35 Oak Ridge Avenue.

TWISTS AND TURNS. The curves of Crescent Avenue, which runs between Norwood and Woodland, are depicted in this card, mailed in 1911 to Mrs. Benjamin S.H. Baker, who resided at 26 Morris Avenue. The building on the right is believed at one time to have been the Heard School.

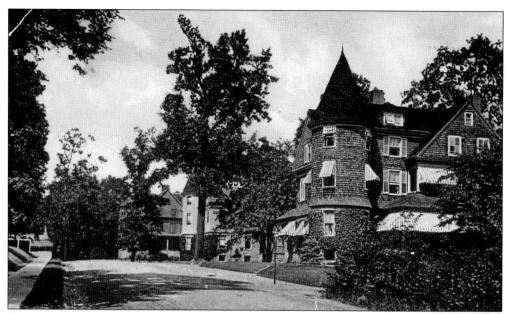

"Lots of Pretty Things." A view of Beechwood Road looking north from De Forest was the card of choice in the fall of 1909 for Mamma, who wrote to Randolph L. Knight in Manchester, Massachusetts, that she "rode the whole length of Fifth Ave. in an automobile—it was fun and we saw lots of pretty things."

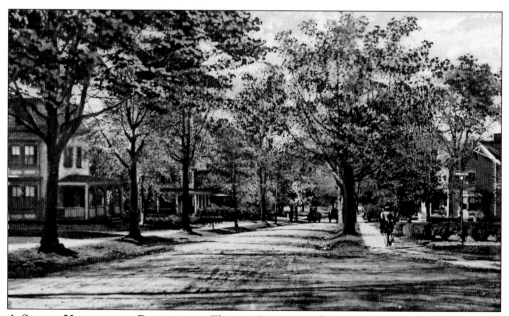

A Scenic View of the Boulevard. This *c.* 1914 postcard features the view looking west on Kent Place Boulevard from its intersection with Norwood, which veers off to the right. The homes on the right have been replaced by the campus of the boulevard's namesake girls' school.

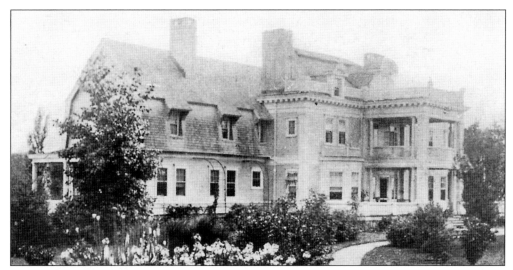

RAZED C. 1939. James W. Cromwell (1842–1932) was a graduate of Haverford College who began his business career working for his father in New York as a dry goods commission merchant. He began spending summers in Summit in the 1880s and in 1899 began constructing his mansion on the Van Blarcom estate on Beekman Road. The Cromwells' daughter Anna lived in the home until it was razed in 1939. In the 1950s the site became the Cromwell Park housing development.

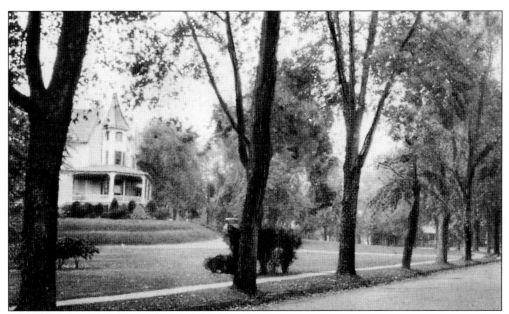

THE "SHOW STREET." In the 1880s, when taxes were low and the incomes of owners were great, more than 20 mansions were built on New England Avenue, which is now lined with brick apartment buildings. At left is No. 66, the former home of John Platt Allen. One historical document says the elaborate homes "made New England Avenue the show street of Summit."

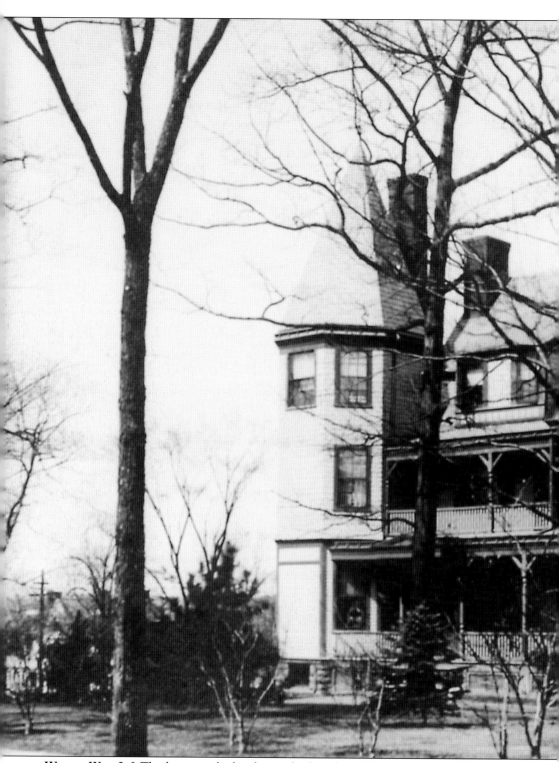

WHERE WAS IT? The house with the sloping backyard on this photo postcard has remained a mystery for more than a decade in the Summit Historical Society's archives. It was sent to

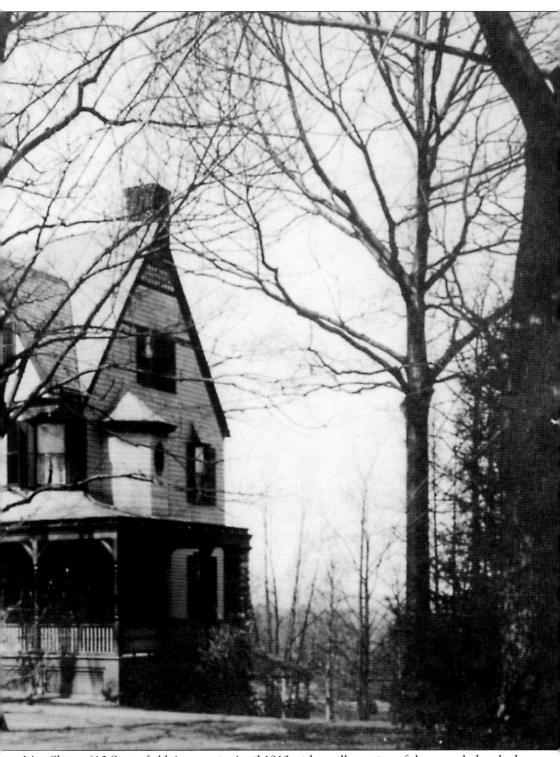

Miss Shine, 610 Springfield Avenue, in April 1913 with an illustration of three newly-hatched chicks glued where a signature might have been affixed. Any ideas?

ONE PARMLEY PLACE. This home was constructed in about 1890 at the Summit Avenue corner of Parmley Place. It was the Alexander Cadoo home, and next door, at No. 5, was the home of A. Cadoo Jr. To the right of the corner was the house of Mrs. C.R. Bard at 144 Summit Avenue. Beyond that, at No. 152, was John H. Eggers, at the corner of Euclid Avenue.

PARMLEY AT SUMMIT. Before tree-lined Summit Avenue was paved, this was the view looking away from town towards Short Hills. The Cadoo house, at left, was built *c.* 1890.

FROM COLT'S HILL. When Colt Castle (later Dr. Reinle's Sanitarium) commanded views from the top of the hill where 15 Pembroke Road now stands, this was the scenery looking north. In the center are rows of greenhouses.

HELLO, YOUNG LOVERS. Many may not be aware that nearly 100 years ago there was a stretch of road in town called Lover's Lane. Among those in the know was a woman named Marie, who sent greetings on this 1906 card to Daisy Robertson on North Sixth Street in Newark.

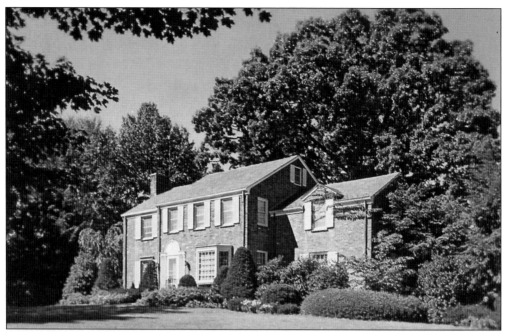

Noted for "Fine Residences." Abundant greenery and mature trees are in evidence in this 1960s postcard. It describes the scene as a typical house in Summit, and says, "This is one of the many beautiful homes in Summit, a community noted for its fine residences." The location in this view is not known.

A More Modern View. Not all of the homes on Hobart Avenue were built 100 years ago. This *c.* 1960 scene shows two women out for a stroll at the corner of De Bary Place.

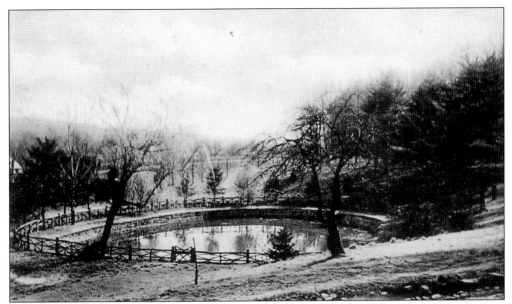

CITY'S RICHEST CITIZEN. In 1888, Gustave Amsinck was noted as Summit's wealthiest resident. He was a partner in a family firm that imported and exported coffee and leather, and had come to America from Germany in 1857. His home stood at 63 Prospect Hill and was destroyed by fire in about 1916. The lake portrayed in this postcard, which bears a 1906 postmark, was behind the house at 160 Springfield Avenue.

SUMMER HOUSE. On the grounds of the Amsinck Estate was what was called the Summer House, which looks like a tree house overgrown with ivy and other greenery. This card was sent by Maria to her mother, Mrs. R.M. Manley, at the Hotel Savoy in Berlin in 1907. It was forwarded to 14 Rue des Pyramides, Paris.

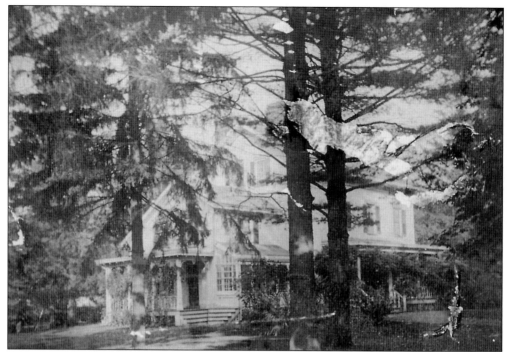

DR. BURLING'S HOUSE. Dr. John Burling (1842–1937) bought 333 Springfield Avenue at the corner of Summit Avenue in 1894. In about 1949 it was razed and replaced by stores. Dr. Burling had two sons and a daughter, Edna M. Burling, who sent this card in July 1907 to Rev. Minot C. Morgan in Lake George, New York. The home was built in the 1840s by Dr. Samuel Parmley.

THE TWOMBLY RESIDENCE. The northwest corner of Beacon Road and Hobart Avenue is where a Revolutionary War signal beacon once stood. In 1908 Henry Twombly built a home at 226 Hobart and moved the beacon monument to a stone wall in the front of the house. Mrs. Twombly was known in Summit as the Mother of Recreation. She helped organize the Summit Playground Committee in 1909, and when it came under the umbrella of the Board of Recreation, she served on that group for 10 years.

WOODLAND AND DE FOREST. Now covered in aluminum siding, the structure opposite Calvary Church at the corner of Woodland and De Forest Avenues is considered Eclectic Vernacular. It was constructed *c.* 1900.

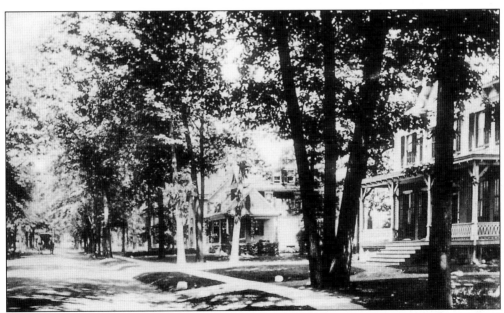

ON PROSPECT STREET. This view focuses upon the homes on the block of Prospect Street between Tulip and Morris. At the center is No. 20, a Queen Anne/Shingle Style home. It first appears on a map of the city in 1900. The porch across the front has columns, and a gabled porte cochere on the right side was constructed with Tuscan columns on a low brick wall.

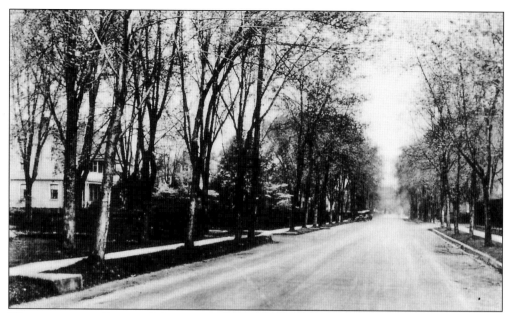

"SCENE AROUND SUMMIT." One guess is that this card labeled "Scene Around Summit, N.J." is a view of Springfield Avenue, but the exact homes pictured have not been determined by historical society volunteers.

THE DRUID HILL SECTION. For many years there has been a grassy island where Mountain Avenue meets Ashland Road. Plymouth Road homes are seen in the background.

Six

HOUSES OF WORSHIP

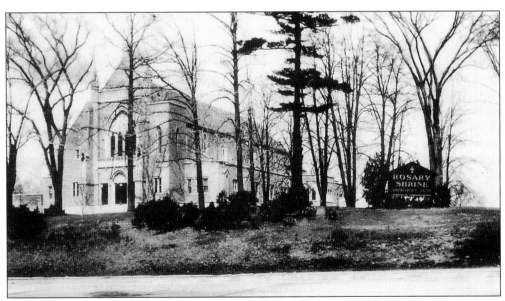

MONASTERY AND CHAPEL. The cloistered Dominican Nuns of the Monastery and Chapel of Our Lady of the Rosary have made Summit their home for nearly 80 years. The building at the corner of Morris and Springfield Avenues was begun in 1926. Construction was halted and started again in 1938. The sisters are dedicated to prayer and rely on donations to exist and survive.

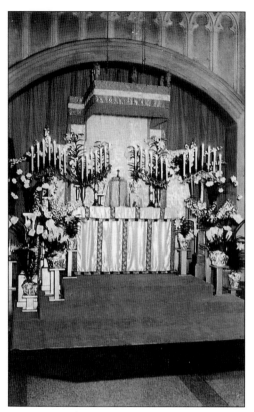

REPOSITORY ALTAR. The photo reproduced on this postcard of the Repository Altar at the Rosary Shrine was taken one year on Holy Thursday.

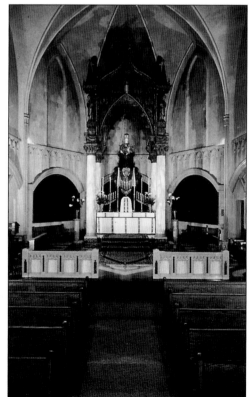

SANCTUARY. The Sanctuary of the Rosary Shrine is described on the reverse side of this card as "a gem of liturgical art" and "the very heart" of the monastery.

HISTORY OF RELIGIOUS SERVICE. The first known Jewish religious service in Summit was held in 1904 in the apartment of a silk weaver. The Unity Club was founded by 12 families in 1923, and its first permanent home was a Civil War–era house at the corner of Morris Avenue and Kent Place Boulevard. It was eventually demolished, and the Jewish Community Center was dedicated in 1954. A marble wall at one entrance was cut to highlight the following verse from Psalms 122:1: "I rejoiced when they said unto me: 'Let us go into the house of the Lord.'"

FIRST CHURCH OF CHRIST, SCIENTIST. Services for Summit Christian Scientists were first held in 1903. The ground on which the present church stands at the corner of Springfield Avenue and Ruthven Place was acquired in 1918. For some time services were held in the house that had stood there. The auditorium in the new church was first used on Thanksgiving, 1938.

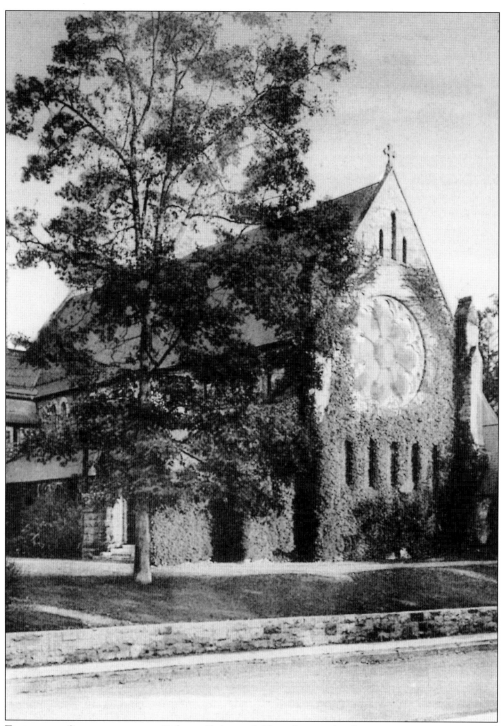

EPISCOPAL CONGREGATION. Calvary Episcopal Church was the first congregation organized in Summit. Its first building went up in 1854 on Springfield Avenue. Today the church is on Woodland at the corner of De Forest Avenue. Calvary was founded under the direction of a summer visitor to town, Rev. Thomas Cook, an Episcopal priest of the Diocese of New York.

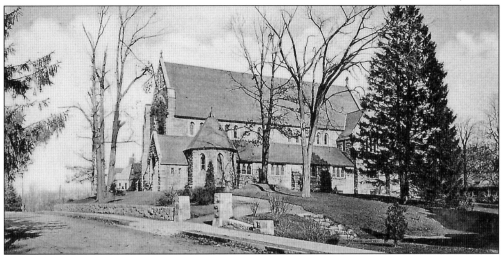

A View Up the Hill. Calvary Episcopal's first church was on Springfield Avenue, and the second was at the corner of Beechwood and Springfield, but it was destroyed in an 1893 fire. Much of the stonework survived the blaze and was used in buildings on the church's current Woodland Avenue campus.

Parish House. After Christmas decorations caught on fire and the interior of the second Calvary Church burned, plans for a new home were begun by the congregation. Under the leadership of Rev. Walker Gwynne, a new Parish House was built at the corner of De Forest and Woodland in 1894. The new church was consecrated in April 1896.

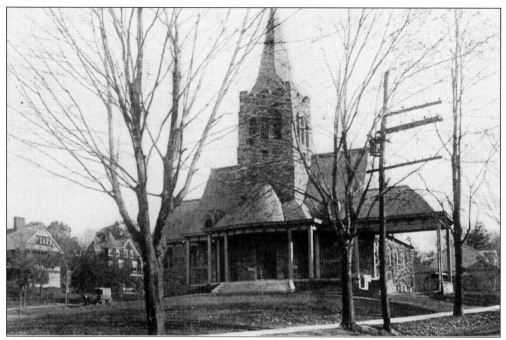

A Church Close to Downtown. Methodists in Summit began meeting in the early 1800s. They began building a church in 1868 at the northwest corner of Morris and Beauvoir Avenues. Membership grew, and in 1888 the church purchased a lot at the corner of De Forest and Kent Place Boulevard for $7,000 from W.H. De Forest. In 1889 the Rev. Elam M. Garton was appointed pastor.

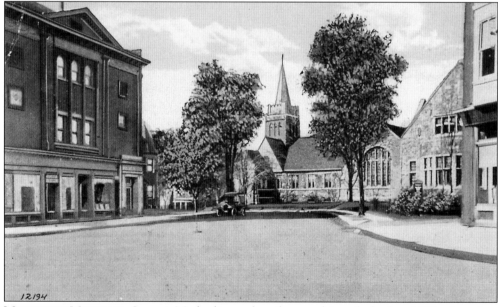

Methodist Meetings. Summit Methodists gathered to worship as far back as 1822, when they held meetings in the area of East Summit that was called Deantown. A Methodist Episcopal Church was formed in 1867, and 37 members elected a board of trustees. This is the view of the current church from Springfield Avenue at Kent Place Boulevard.

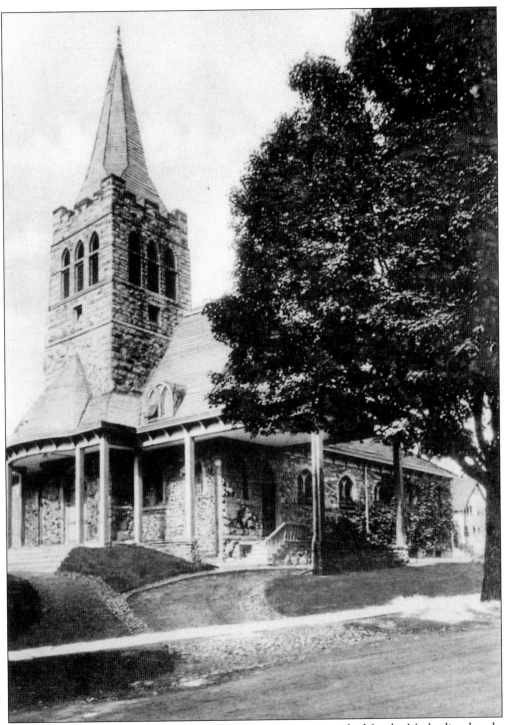

A STATELY STEEPLE. On October 23, 1889, the cornerstone was laid for the Methodist church. The building cost an estimated $44,000. After World War II, to extend the Church School facilities, it was decided to demolish the old parsonage and buy more land on De Forest. A new parsonage was purchased at 17 Sherman Avenue.

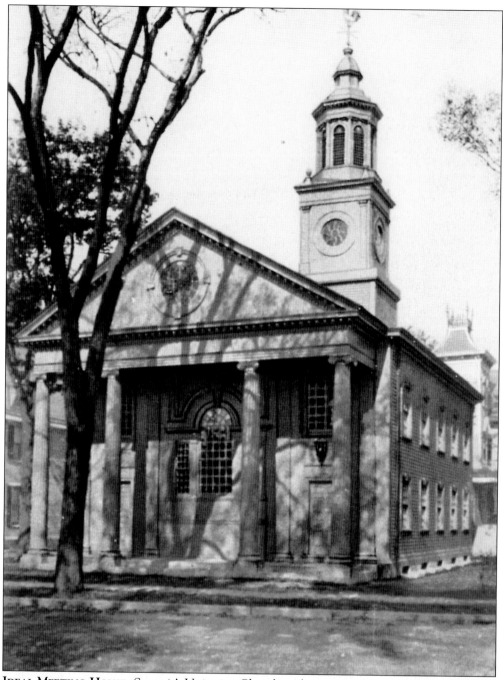

IDEAL MEETING HOUSE. Summit's Unitarian Church at the corner of Springfield and Waldron Avenues was declared "The Ideal Meeting House of America" by the Architectural League of New York when it was constructed. The architect was Joy Wheeler Dow.

ARCHITECT WAS A CONGREGATION MEMBER. Originally known as All Souls', this church was built at 4 Waldron Avenue in 1913 and today is Summit's Unitarian Church. Architect Joy Wheeler Dow was a member of the congregation who lived with his family in a house he built at 45 Bellevue Avenue.

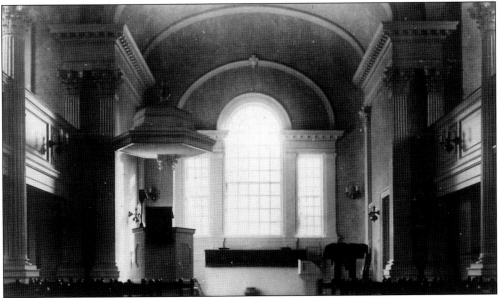

ALL SOULS' CHURCH. This card highlights the soaring ceiling of architect Joy Wheeler Dow's All Souls' Church, now the Unitarian Church. Mr. Dow, whose name at birth was John Augustus Dow, also designed the homes at 21 Badeau Avenue, called "Silvergate," and 18 Badeau, "Kingdor."

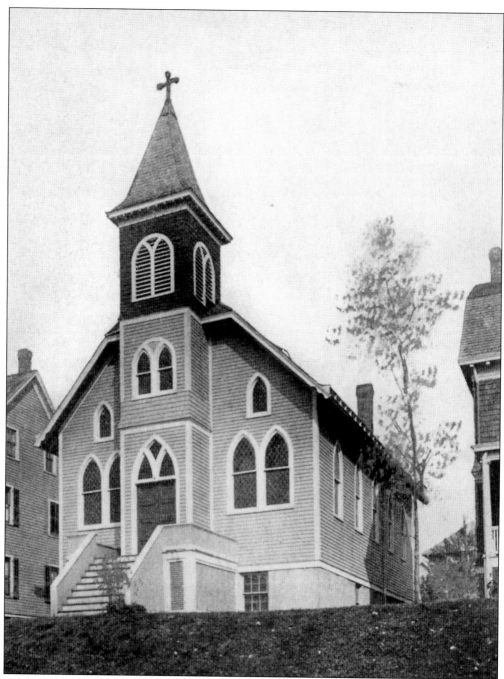

FOUNDED BY 37 MEMBERS. The 37 founding members of the Swedish Evangelical Lutheran Salem Congregation were immigrants who came to Summit in the 1880s and 1890s. The church, sold in 1959 to Mount Olive United Holiness Church of America, was designed by Richard S. Shapter. The building stands in the shadows of Overlook Hospital at 217 Morris Avenue.

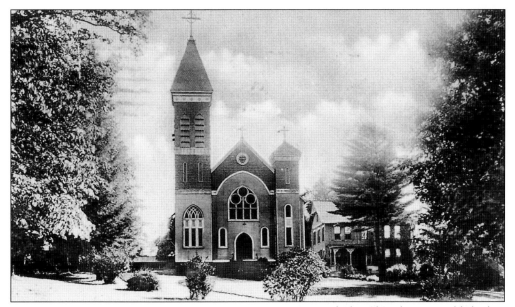

SAME SITE, DIFFERENT STRUCTURE. St. Teresa's Roman Catholic Church was established in 1862, the cornerstone was laid in 1863, and the church incorporated in 1864. On November 28, 1886, the cornerstone of a new wooden church was laid on Morris Avenue, with the original stone building incorporated as the sacristy. In 1923 the building was moved across the street when a larger church was constructed, and became Memorial Hall.

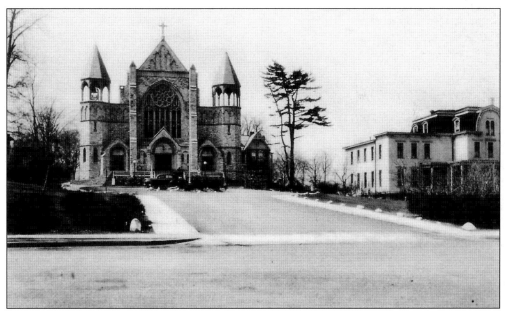

BECAME A PARISH IN 1874. Until the 1860s, a priest from Madison came to Summit every other week to say mass. The 1923 stone church building incorporated a portion of its 1863 predecessor as its sacristy. In the early 1920s the parish reported it had 5,000 members, which accounted for nearly half the city's population.

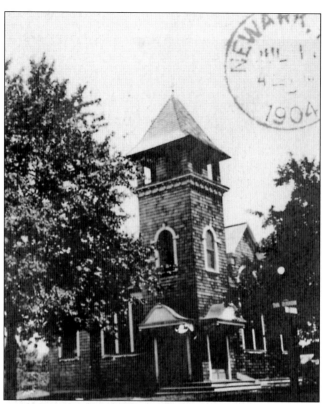

SUNDAY SCHOOL CLOSE TO HOME. At the end of the nineteenth century, children in East Summit needed a Sunday school closer to home than the center of town. Classes were offered in a rail station and then a private home, but when enrollment rose above 60, the parent Methodist church realized a building was needed. It went up at 120 Morris Avenue at the corner of Russell Place and was consecrated in 1898.

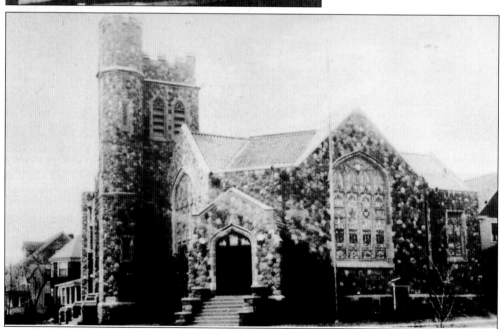

NAMED TO HONOR REVEREND. In 1922, the East Summit Methodist Episcopal Church became Oakes Memorial Church following the death of Rev. Jay Adams Oakes. The stone structure, dedicated on May 18, 1919, to replace a shingle church, is currently called the Oakes Outreach Center and is home to nonprofit organizations.

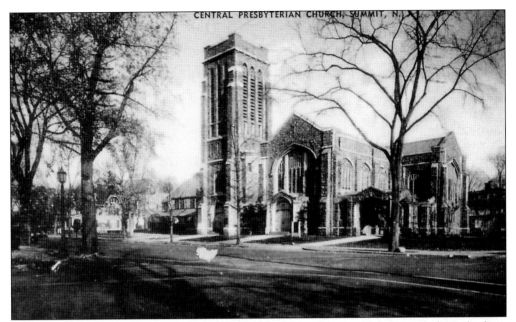

FOUNDED AFTER A DISPUTE. After a dispute between Summit Calvinists and Methodists, Calvinists seceded from the Franklin Chapel Association and formed their own congregation in 1870. In 1872 the original Central Presbyterian Church went up on Maple Street. The current stone building was completed in 1924.

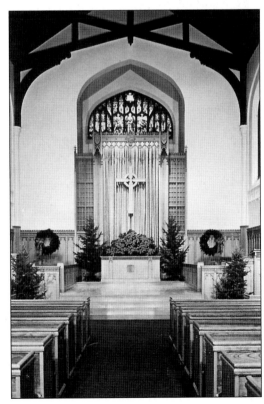

SEASON'S GREETINGS. Shown decorated with wreaths, dozens of poinsettia plants, and symmetrical evergreens is the altar of Central Presbyterian Church on Maple Street. In 1968 the church built its Christian Education Annex at the corner of Morris Avenue and Elm Street.

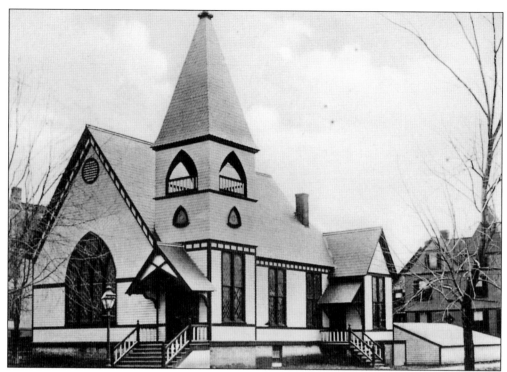

FIRST A CHURCH, THEN A LAUNDRY. Although the postcard of this building at 1 Locust Drive was labeled First Baptist Church, records show it was that congregation's second home. Later it was the Enterprise Laundry owned by Richard L. Corby. The business burned in 1932 and the site is now St. Teresa's parking lot adjacent to its school building.

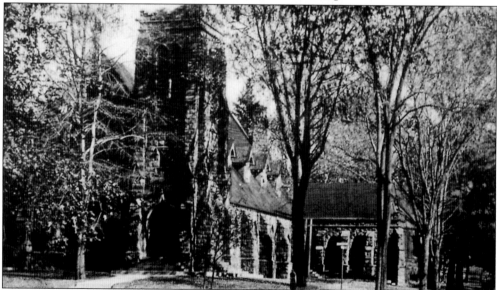

SET TO SEAT 350. The architects of Christ Church on Springfield Avenue were C. Fred Bertrand and John N. Cady, who also designed Old Town Hall at 71 Summit Avenue. The seating capacity of the church was 350, and the style is English Gothic. The church was originally the First New Baptist Church of Summit.

Seven

BUSINESS AND INDUSTRY

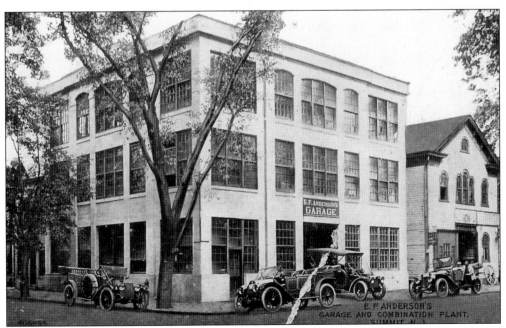

GARAGE AND COMBINATION PLANT. A three-story reinforced concrete garage on Broad Street was owned by Emmanual F. Anderson when it opened in May 1911. He advertised himself as a wagonmaker and blacksmith, and, with an eye to the future, as an agent for Oldsmobile, Reo, Rauch and Lang Electrics, and Diamond T Trucks.

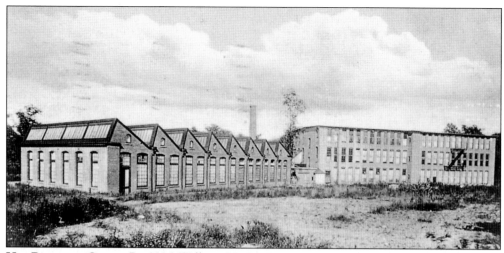

HIS BUSINESS GREW. By 1896 William H. De Forest Jr.'s Summit Silk Mill at 430 Morris Avenue had 240 employees. In 1899 he added a new three-story adjoining building. By 1923 three silk mills in town comprised the city's most prominent industry, but by 1926 or so Mr. De Forest had closed his operation. From 1937 to 1964 the building was leased to a sportswear firm, and then it was razed.

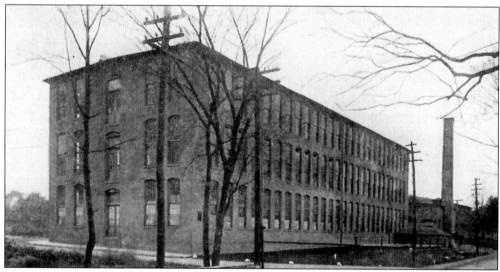

EARLY INDUSTRY. In June 1892, William H. De Forest had purchased the Summit Rubber Company building at the corner of Morris Avenue and what is now Weaver Street. According to an article in the *Summit Record* at the time, the site was "soon to be fitted for the manufacture of all grades of silk, with 100 looms."

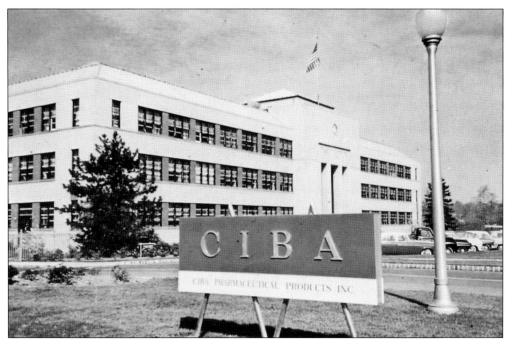

A CORPORATE GIANT. Ciba was founded in 1884 by French chemist Alexander Clavel of Lyons and set up shop in Summit in 1937. There were 98 employees in five buildings. In the 1990s the international pharmaceutical firm merged with Sandoz to become a new company known as Novartis.

SMILING TOUR GUIDES. According to the caption on the reverse of this undated postcard, "Ciba guides conduct scheduled tours for professional, student, and community groups." The pharmaceutical firm's campus at the north end of Morris Avenue in Summit comprises 80 acres.

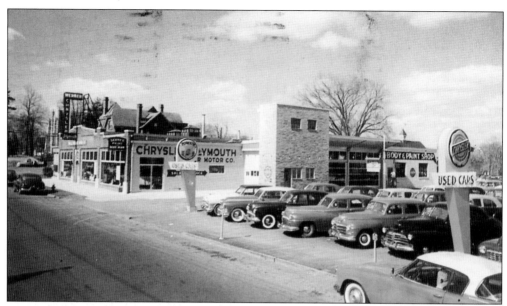

IN THE MARKET FOR AN AUTO? In March 1955, R.A. Kinsey of 141 Beechwood Road was sent this card by George C. Hauck, an employee of the Werner Motor Company who wanted to offer "a wonderful deal on a beautiful Chrysler or Plymouth." The Springfield Avenue site across from City Hall is still home to an auto dealership, with the roof lines of the Rosary Shrine visible at far left.

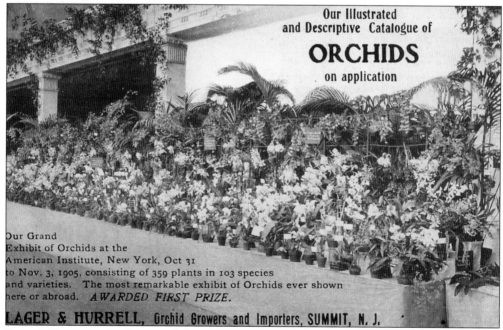

Our Illustrated
and Descriptive Catalogue of

ORCHIDS

on application

Our Grand Exhibit of Orchids at the American Institute, New York, Oct 31 to Nov. 3, 1905, consisting of 359 plants in 103 species and varieties. The most remarkable exhibit of Orchids ever shown here or abroad. *AWARDED FIRST PRIZE.*

LAGER & HURRELL, Orchid Growers and Importers, SUMMIT, N. J.

EXOTIC ORCHIDS. At the turn of the century, Lager & Hurrell operated an orchid growing and import firm at 424 Morris Avenue, now an athletic field. By the 1960s the company offered 10,000 varieties, including the Summit Snow and Summit Queen. This card promoted a display that the company exhibited at a 1905 show in New York. In 1977 Lager & Hurrell, still family-owned, relocated to Georgia.

92

SENT TO FRIENDS AND FAMILY. Custom gift and fruit baskets were created at 55 Summit Avenue by employees of the Central Market. They sent postcards of a sample offering and suggested the baskets were a "universally popular gift" that would be appreciated by service men and women.

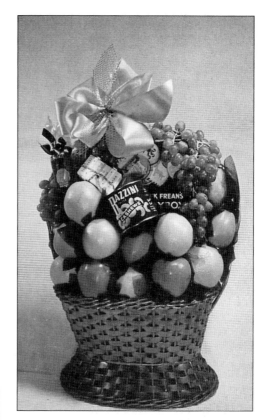

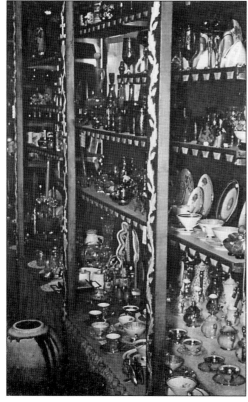

GIFT SHOP DOWNTOWN. In the 1950s and 1960s, Albers Gift Shop at 459 Springfield Avenue billed itself as "Your Little Shop of Big Buys and Old World Charm." It carried gifts including porcelain, vases, jugs, wall plates, crystal, and china. This card offered the bearer a 10 percent discount on a purchase.

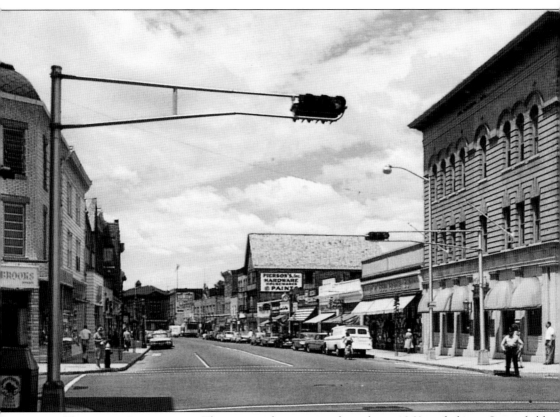

A BUSTLING DOWNTOWN. This postcard was created in about 1960 and shows Springfield Avenue headed west from its intersection with Maple Street. Brooks anchors the view at the left, with the former Roots clothing store across the street in a building that once housed Summit's post office.

Eight

HOTELS AND RESORTS

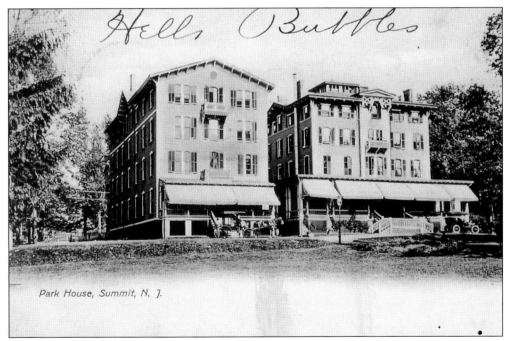

Park House, Summit, N. J.

A FORTUNE WAS LOST. Built in 1871–73 on what is now Woodland Avenue across from Lincoln School, the hotel known as the Park House was the creation of Jayme Riera. By 1884 Mr. Riera had lost a fortune estimated at more than $2 million. That year he sold the hotel and much of his real estate holdings at auction for $18,000 to William De Forest.

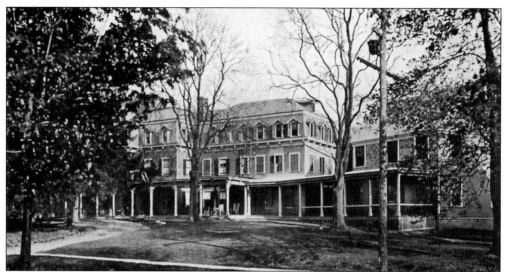

ON A 7-ACRE CAMPUS. In Summit's days as a summer resort destination, The Blackburn housed a full complement of 150 guests in its main hotel building on Springfield Avenue and six cottages scattered on its 7-acre campus. Attractions included a casino, tennis courts and a bowling alley. In the summer of 1928 construction on a new hotel at the same site began, and today the address belongs to The Grand Summit Hotel.

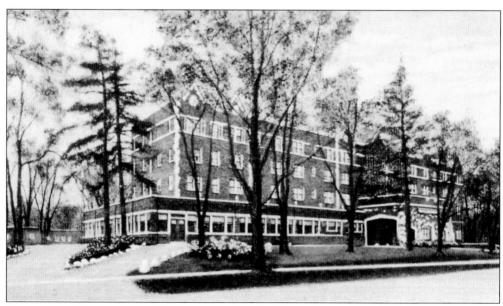

HOMETOWN HOSPITALITY. What began as The Blackburn House in 1869 evolved by 1929 into The Hotel Suburban, with 135 rooms and flexible number of apartments. The hotel reopened just months before the 1929 stock market crash, and a number of formerly wealthy Summit residents who lost their homes moved into the hotel, many bringing servants with them.

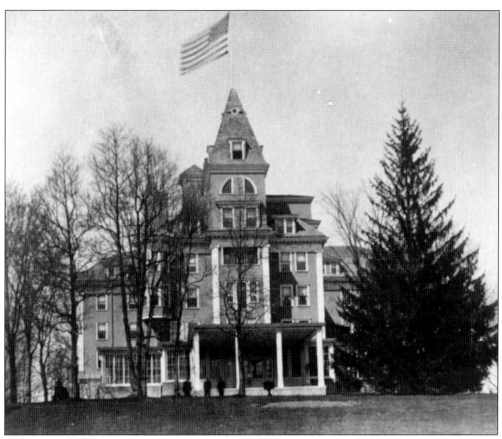

Much-Loved Landmark. Before it was demolished in the early 1950s and replaced by an office building and parking lot, the Beechwood Hotel on De Forest Avenue had become a full-time home for 89 people, some of whom had resided there for years.

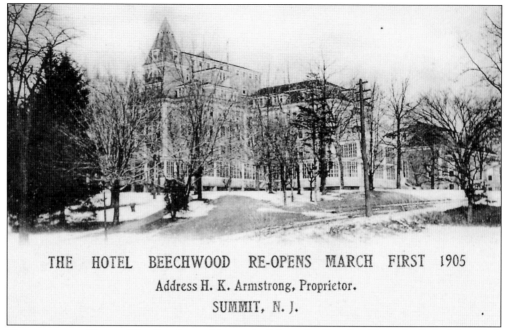

THE HOTEL BEECHWOOD RE-OPENS MARCH FIRST 1905
Address H. K. Armstrong, Proprietor.
SUMMIT, N. J.

COMMANDING VIEWS. The Beechwood began its life as the Parmley Place, built for New York dentist Dr. Samuel Parmley in 1851. Enlarged in 1893 to become the hotel, it featured 300 feet of open-air porches that offered panoramic views of town.

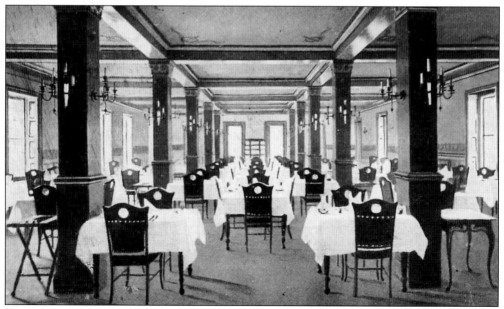

DOWNTOWN ACCOMMODATIONS. The Beechwood offered rooms for up to 250 guests at a time in its heyday. It had a grand ballroom and 50 horse stalls. This postcard view features the hotel's dining room, with the tables set with linen cloths for dinner.

Nine

HOSPITALS

FOUNDED BY DR. LAWRENCE. When this card was sent in 1908, Overlook Hospital had opened its doors only two years before. The founder was Dr. William H. Lawrence Jr., who lived with his family at the hospital in its early days. In 1906 Overlook had 16 private rooms and 2 wards, and doctors announced that "no tuberculosis, mental, contagious, or otherwise objectionable cases" would be admitted.

HELLO, BERTHA. When this view of New England Avenue and Tulip Street went to Bertha Arnold in Ulster, Pennsylvania, in 1906, George Manley's Fair Oaks mansion seen in the distance had been a sanitarium for four years. The home was built in 1880 by Mr. Manley, who at one time chaired the Township Committee.

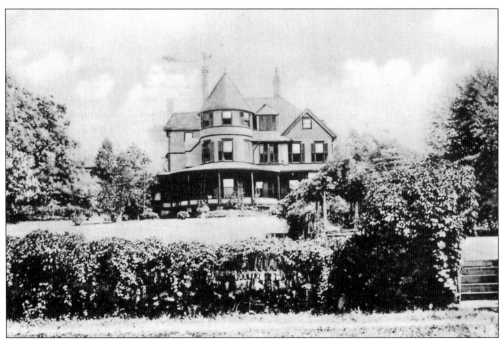

FAIR OAKS SANITARIUM. In 1902, Dr. Eliot Gorton and Dr. Thomas P. Prout established the Fair Oaks Sanitarium in the Manley home at 26 Locust Drive. The house was razed in 1939 and replaced by garden apartments. The healthcare facility's address had switched to 19 Prospect Street.

"Proper Environment." When Fair Oaks opened just after the turn of the century, its founders said the concept was that, given the proper environment, patients with "mental afflictions" could make "satisfactory adjustments to everyday living." In its first 50 years of operation, more than 9,000 patients were treated, some of whom stayed at the sanitarium for years at a time.

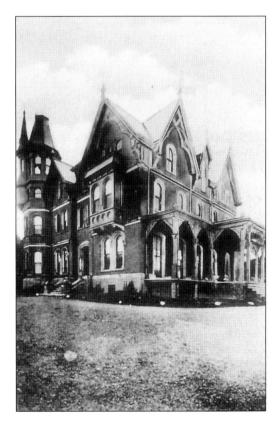

Where a Herd of Holsteins Grazed. Colt Castle, at one time home to a sanitarium, was razed in 1930. Its 117 acres were developed into the city's Woodland Park section, an area that includes Colt, Warwick, Winchester, Pembroke, Dorchester, and Portland Roads.

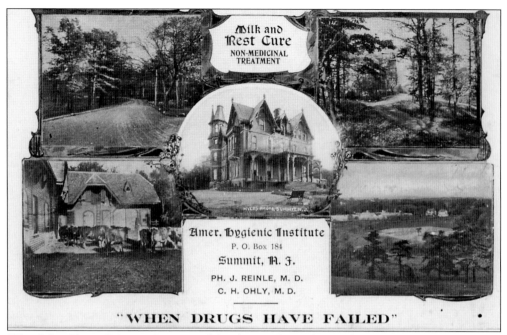

Milk and
Rest Cure
NON-MEDICINAL
TREATMENT

RIVERS PHOTO SUMMIT N.J.

Amer. Hygienic Institute
P. O. Box 184
Summit, N. J.
PH. J. REINLE, M. D.
C. H. OHLY, M. D.

"WHEN DRUGS HAVE FAILED"

"THE MILK FARM." At an elevation of 502 feet, Colt Castle stood where 15 Pembroke Road is now. It was built by Morgan C. Colt, of the family famous for its firearms, in 1870. In 1903 Dr. Philip Reinle bought the castle and converted it to a sanitarium. It was known as the Milk Farm by locals because milk from a resident herd of Holsteins was said to be the main menu item for guests on a "milk cure" diet.

Ten

PARKS, MONUMENTS, AND SPORTS

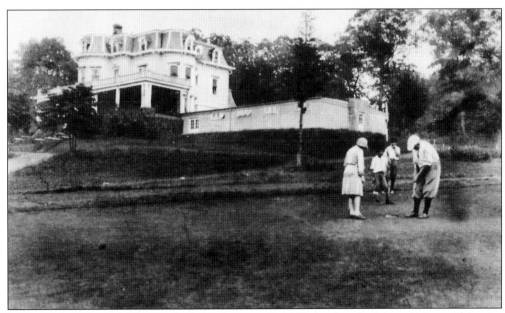

HITTING THE LINKS. This card of the Summit Golf Club advertised it as being within city limits, but it was actually in the Murray Hill section of Berkeley Heights. The club failed during the Depression in the early 1930s, and eventually developers built 85 houses on its extensive grounds. The mansard-style former clubhouse remains as a private home.

AN EXPANSE OF GREEN. This 1928 card illustrates the view towards the downtown intersection of Union Place and Maple Street from the Village Green, then known as Bonnel Park. It was named for the Summit family whose members at one time owned a major portion of the property that now makes up the city's center.

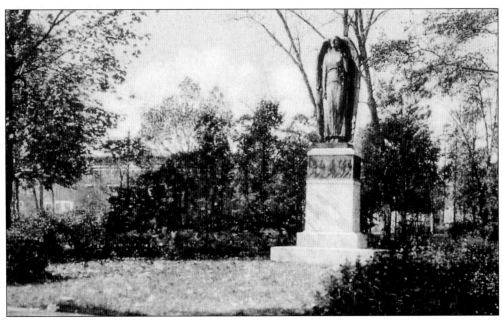

A MONUMENT TO LIVES LOST. On January 2, 1926, the 7-foot Angel of Peace monument was dedicated in Bonnel Park, an area now known as the Village Green. The sculptor was Edith Baretta Parsons, and in the front is carved the following message: "To honor the men of Summit who gave their lives in the World War."

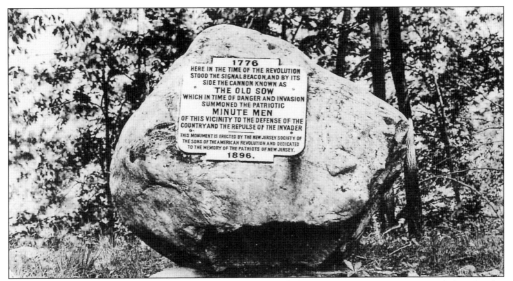

SIGNAL BEACON 10. Summit is located on the Second Watchung Mountain, and during the Revolutionary War, Gen. George Washington arranged for Signal Beacon No. 10 to be created here. It was accompanied by a cannon to warn of a British attempt to conquer the mountain at the pass now known as Hobart Gap. In 1896 the New Jersey Society of the Sons of the American Revolution dedicated a plaque on the spot, at 226 Hobart Avenue.

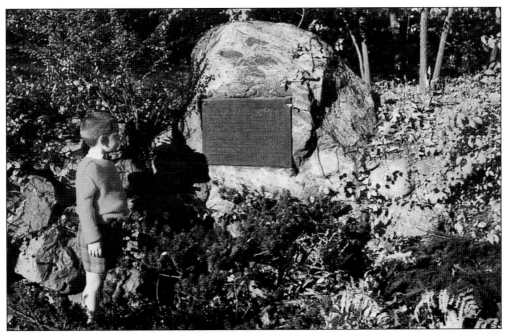

A FOUR-SIDED PILE OF LOGS. Signal Beacon No. 10 on Hobart Avenue was a four-sided pyramid of logs in descending size. Brush was burned within it to create smoke as a warning to distant troops that the British were advancing. When a home was built at 226 Hobart, the plaque was moved to a rock within a stone wall.

LOVE AND BEST WISHES. Now a popular destination for walkers, runners, and those pushing strollers, Briant Pond was once known as Spring Lake. That was probably the reason this card was sent to Corinne H. Lum in the shore town of Spring Lake Beach in the summer of 1907 by someone who wrote, "Dearest Win, Why don't you write, you naughty girl, have you crossed me off your list entirely? Love & best wishes."

RIVER OFFERS RECREATION. At the uppermost source of the Passaic River is a network of streams behind the center of Mendham that form a brook that proceeds to wind its way 90 miles towards Newark Bay. The Summit Historical Society has in its collection a dozen varied postcard views of the river, testimony to the important role it has played in the lives of local residents.

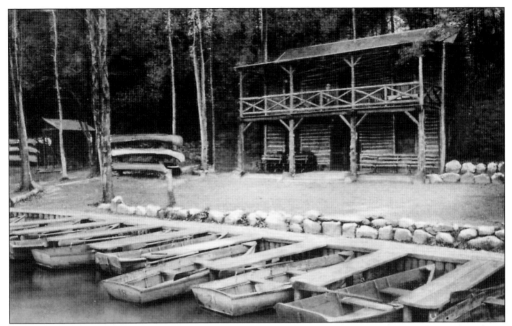

THE LAKE AND ITS SHORES. This scene that looks like a lakeside setting in the heart of the Adirondacks was published by the Union County Park Commission to promote Lake Surprise. Over a July Fourth weekend in 1931, an estimated 22,500 visitors "enjoyed the charm of the lake and its shores," according to a front-page story in the *Summit Herald* the next week.

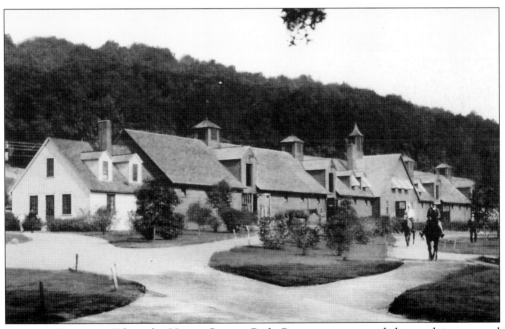

STATELY STABLES. When the Union County Park Commission created this card, it was used to promote the riding stables in the Watchung Reservation. The facility is still operated by the county, but has a Mountainside address.

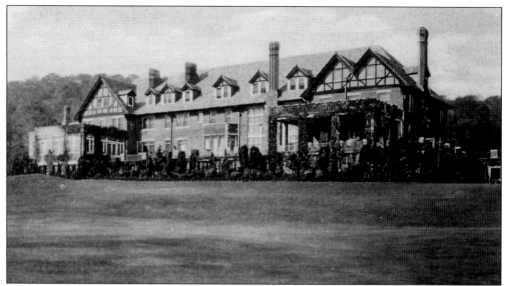

A Stately Clubhouse. Although there is no evidence to suggest Baltusrol Golf Club in Springfield ever had a Summit address, an enterprising postcard manufacturer must have decided to bend the truth a bit and capitalize on the club's national fame. It was organized in 1895 by Louis Keller, publisher of the *New York Social Register*, who built the original clubhouse on his own farmland.

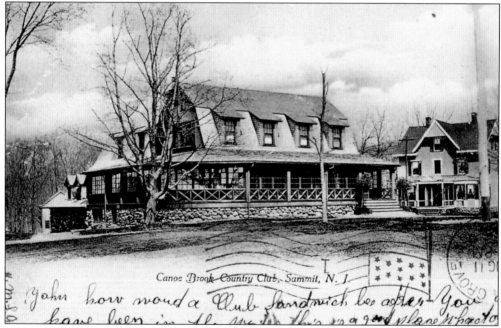

Canoe Brook Clubhouse, 1905. By 1901 a number of Summit's summer residents were calling the city their year-round home. A group of subscribers acquired acreage that straddles the line between Summit and Short Hills and declared it their "land of pleasure in the sea of suburbia." The links opened in the fall of 1902.

108

ACKNOWLEDGED WITH THANKS. Postmarked in Asheville, North Carolina, on May 17, 1920, this card was sent to Mrs. F.B. Beach at 3 Edgemont Road. The following message was from Mrs. Charles F. Bassett, treasurer: "The Playground Committee acknowledges with thanks your contribution to the season's work." It was this committee in 1913 whose members created plans for a playground, three tennis courts, and a track behind the then-new Brayton School.

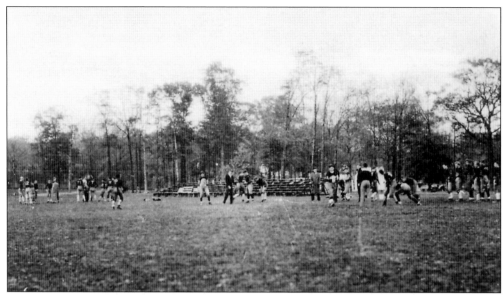

A SOLDIER'S MEMORIAL. After the 1918 Armistice, the subject of a war memorial in town was discussed. A Soldiers' Memorial Committee raised funds to purchase the 25 acres that comprise Soldiers' Memorial Field on Ashland Road, and later reorganized as the city's Board of Recreation. After it was dedicated in 1928, the field was used for baseball games and for Summit High School football games and track meets.

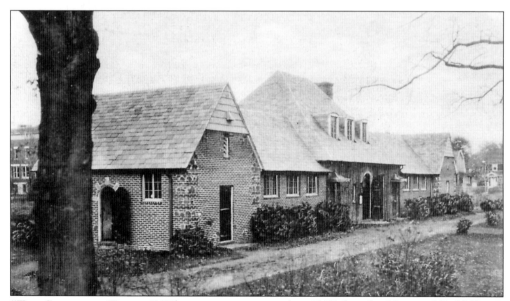

"THE CROWNING TOUCH." When it was announced in 1927 that the Memorial Field House would be built, a local newspaper predicted it would "add the crowning touch" to the site. It was reported recreation commissioners Gertrude S. Gross and Frances D. Twombly supervised construction of the field and field house.

Eleven

CLUBS AND
ORGANIZATIONS

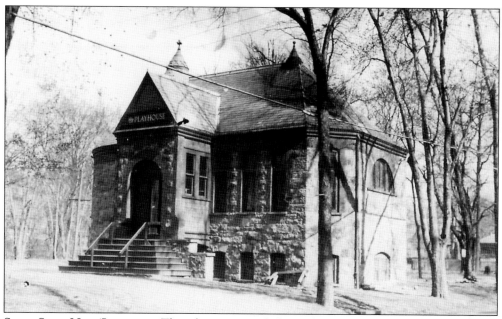

SAME SITE, NEW IDENTITY. This photo postcard shows the words over the entrance to this building had not yet changed from "Library" to "Playhouse." The books were moved a few blocks away to Maple Street in 1911, and the theater group formed in the spring of 1918. The first director was Norman Lee Swartout, the first stage manager was Jack Manley Rosé, and the first costume manager was Marjorie Cranstoun Jefferson.

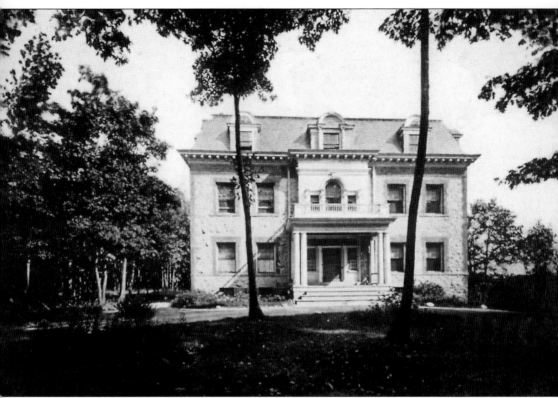

FOUNDED TO HONOR A SON. The Arthur Home for Destitute Boys was founded in 1881 through an effort spearheaded by Georgianna Kingle Holmes, whose only child, a son, suffered an agonizing death after he was bitten by a rabid dog. The organizers were assisted by Calvary Church, and the stone home pictured went up in 1901 at 80 Pine Grove Avenue. It came down in 1948 and was replaced by the homes on Pine Ridge Drive.

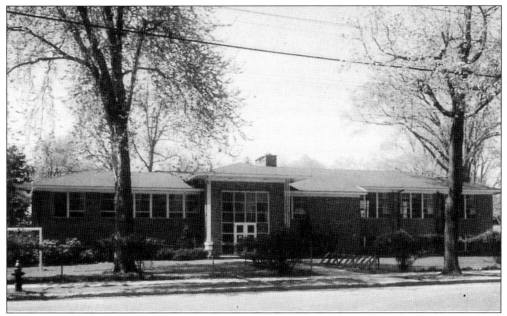

First Home Was a Frame House. In 1918, the YWCA in Summit was organized in a former Presbyterian chapel on Maple Street. In 1922 the YW was given the old frame house of Jonathan Bonnel on Morris Avenue between Maple and Prospect by his daughter. It was destroyed by fire and in 1949 the current facility was built.

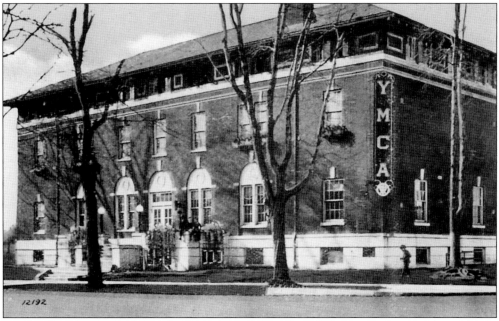

In No Uncertain Terms. The YMCA in Summit was first organized in 1886, and had a handful of headquarters in the vicinity of downtown. In 1910 the YM bought a site on Maple Street from the Summit Home Land Company for $11,000, and terms stipulated the organization must construct a building that would cost at least $50,000 within two years.

A Place in the Neighborhood. In the early 1900s most of the residents of North Summit were Syrians, Armenians, Polish Jews, Italians, Irish, Bohemians, Russians, Belgians, and Turks. Residing more than a mile from downtown left them with few educational, religious, or social opportunities. In 1900 a four-room rented site at 518 Morris Avenue became the Neighborhood House for their use, founded under the leadership of the pastor of Central Presbyterian Church, Rev. Theodore White. Today it holds a retail store adjacent to the driveway of Washington School.

PROMINENT PASTOR'S DAUGHTER. Mary Ogden White (1863–1938) aided her father in the creation and operation of the Neighborhood House. She was one of the early presidents of the Fortnightly Club, was an ardent suffragist, and was active with the group that founded the city's free and public library.

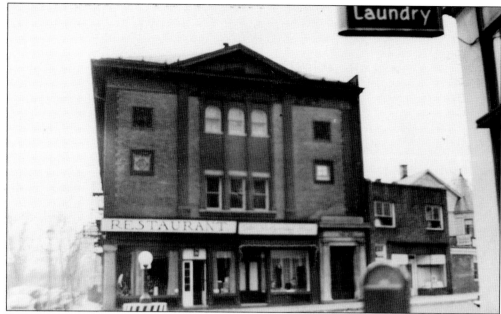

HOME TO MASONIC LODGE NO. 2. The structure at 6 Kent Place Boulevard was constructed in 1894 by Joel Van Cise, and in its early days held rallies hosted by the Women's Christian Temperance Union. In 1920 Overlook Masonic Lodge No. 163 bought the site and spent $57,858 on improvements including the conversion of a balcony to an Italian Renaissance style meeting room.

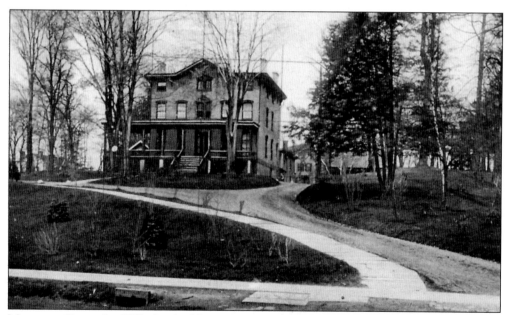

MEMBERS ONLY. In 1859 this building constructed by Dr. Samuel Parmley opened as Billy Stoughton's Boys' School. From the 1870s to 1896, it was the Highland House, a boarding establishment. Then it became home to the Highland Club, a social organization for men. Its address was 29 De Forest, where a commuter parking lot exists behind a drugstore today.

Twelve

MISCELLANEOUS IMAGES

FRIENDLY FACES. It is anyone's guess whether these three boys in straw hats ever actually set foot in Summit. It is more likely this card was a standard one that had its lettering adapted to fit an assortment of locations.

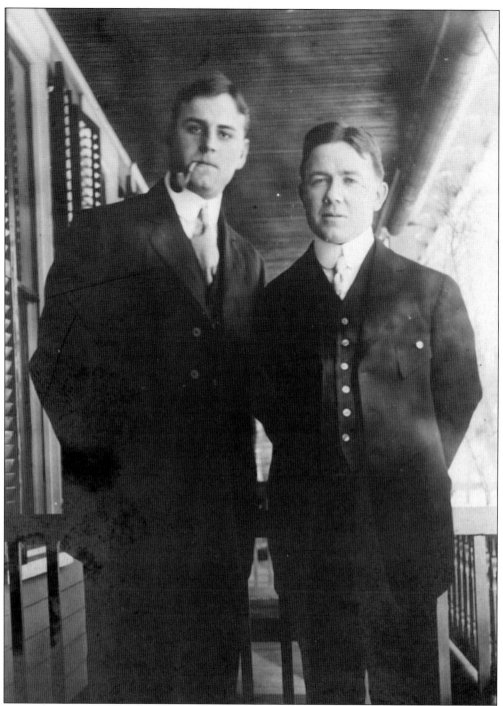

LITTLE IS KNOWN OF THEIR IDENTITIES. It was a New Providence resident, Anita Gorgia, who provided the historical society in 1997 with the cards on these facing pages. The men, she said, were friends of her uncle named Harry Johnston and Lawton Morris. No trace of Mr. Morris is found in local records, but Mr. Johnston was employed by the DL&W Railroad from 1901 to 1925. From 1925 on, city directories do not list any members of a Johnston family.

Was She Harry's Mother? In city directories published from 1901 to 1925, Alice Johnston, widow of George, is listed as residing at 10 Beauvoir Avenue, where it appears this postcard photo and the one opposite were taken. In the days before cameras were commonplace, people often paid traveling photographers to create images on postcards of themselves, their families, their businesses, and their homes.

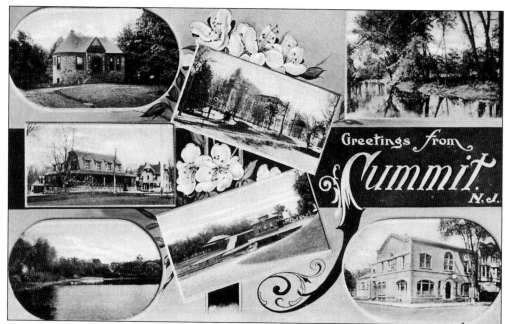

GREETINGS FROM SUMMIT. Those who could not decide from among the dozens of postcard options available in the city in 1908 could opt for this one, which contains seven images. From upper left, clockwise, they are as follows: the Summit Library (now the Playhouse Association), the Beechwood Hotel, the Passaic River, the YMCA (on Springfield Avenue at Maple Street), the railroad station, Spring Lake (now Bryant Pond), and an early clubhouse at Canoe Brook Country Club.

A BRIDGE BETWEEN TWO TOWNS. At Summit, the Passaic River forms the boundary between Union and Morris Counties. The bridge pictured was built in the 1890s.

ON THE BOULEVARD. Before it had the words "Kent" and "Place" added to its name, one of Summit's major east-west thoroughfares was known simply as The Boulevard. The gentleman pictured here in an early auto had the road to himself.

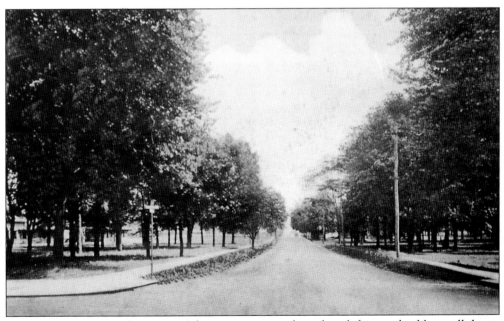

ON THE AVENUE. The lettering on the street signs on the pole at left is not legible, so all that is known of this card is that it was mailed from Bernardsville to Morristown in 1912 and is labeled "Park Avenue, Summit, N.J."

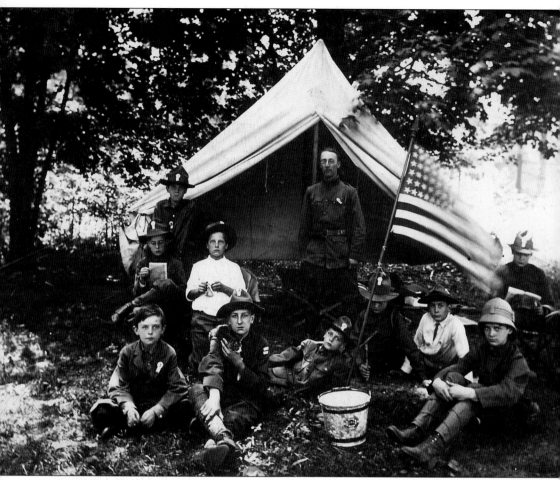

WOODCROFT INDIANS AND SCOUTS. Someone penciled on the reverse of this postcard "1912 Troop #1," and that is all that is known about its subjects. Over the years it has been said nature writer Ernest Thompson-Seton set up his first tribe of Woodcroft Indians in Summit. It has been written that Sir Robert Baden-Powell drew most of his ideas from the Native American tribes when he organized the Boy Scouts in England in 1907–08 and in America in 1910, so possibly Summit can claim to be the birthplace of the Boy Scout movement.

Summit, New Jersey

KBG5736

Eric Senkowsky

LOUD AND CLEAR. Ham radio buff Eric Denkowsky of 40 Dale Drive mailed this acknowledgment to a fellow operator in Short Hills in 1962. He advised him that the "readability" of a recent signal was 100 percent, and that he would like to try to meet the Short Hills man "someday with Lane at South Mountain."

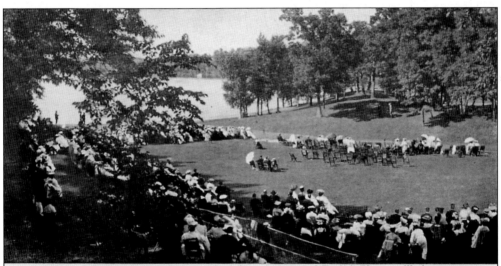

The *BEN GREET* Company of English Players will give two open-air-plays on the Kent Place School lawns, SUMMIT, N. J., SATURDAY, MAY 23:—"Twelfth Night," 4 P. M.; "The Tempest," 8:15 P. M. Reserved Seats, signifying advantageous places on the grounds, or seats in the Hall in case of rain, $1.50 for each play. Tickets on sale at Music Hall Pharmacy, Orange; Roger's Drug Store, Summit; Green's Pharmacy, Summit; Smith's Drug Store, Morristown; DeHart's Drug Store, Madison.

SHAKESPEARE IN SUMMIT. This advertising postcard was mailed in May 1908 to John Hillier Hart, Esq., on Badeau Avenue. The Ben Greet Company of English Players was headed to town to present open-air productions of *Twelfth Night* and *The Tempest* on the lawn of Kent Place School, and reserved seats were $1.50.

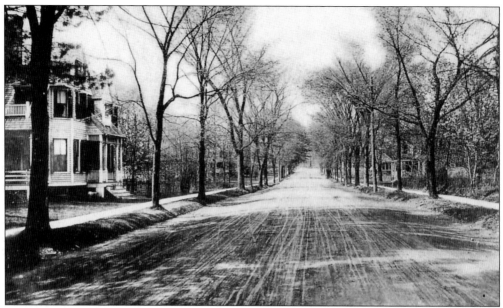

TIRE RUTS IN THE ROAD. Some of the homes on Waldron Avenue are depicted in this view. The dirt road shows evidence of the narrow tires used on early automobiles, and probably ruts from carriages, too.

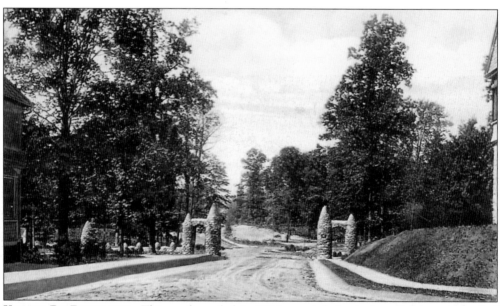

YET TO BE DEVELOPED. This card, mailed in 1911, carried the image of the upper end of Beechwood Road, closest to downtown and its intersection with Euclid Avenue. The developers of housing in the area constructed stone archways at the entrance to the site, and they are depicted also on a piece of ruby flash glass in the collection of the Summit Historical Society that may have been used as a premium by the builders.

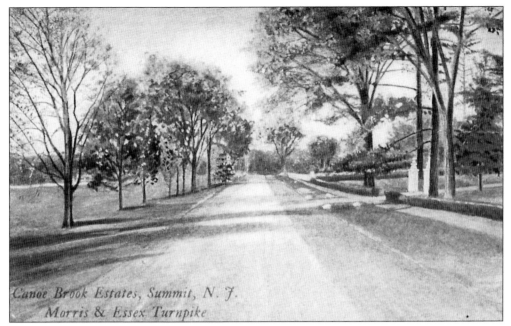

Canoe Brook Estates, Summit, N. J.
Morris & Essex Turnpike

CANOE BROOK ESTATES. In April 1912, Caxton Brown of Shadyside Avenue bought 76 acres of land at River Road and the Morris Turnpike for development. In 1913, the Prospect Hill Corporation offered for sale the Canoe Brook Estates. Possibly this reproduction of an artist's rendering was sent to prospective homeowners.

THE CITY'S NAMESAKE STREET. A lone automobile chugs its way up Summit Avenue in this 1913 postcard, sent by someone named Bella to a friend in Brooklyn.

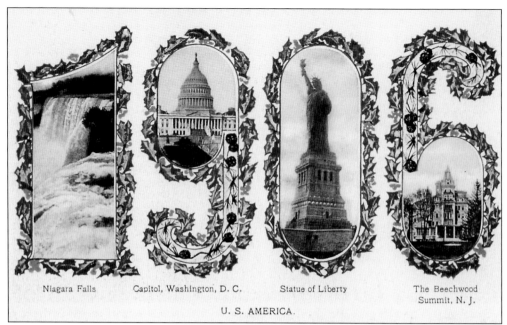

Niagara Falls Capitol, Washington, D. C. Statue of Liberty The Beechwood
 Summit, N. J.

U. S. AMERICA.

A Proud Town. There is no doubt those who marketed this 1906 card felt Summit was a worthwhile destination for travelers in America. From left are Niagara Falls, the U.S. Capitol Building in Washington, D.C., the Statue of Liberty, and The Beechwood Hotel.

Mature Trees. The tagline on this card is "Lenox and Whittredge Roads from Springfield Avenue, Summit, N.J." It was mailed from Short Hills in June 1931 to Sweden.

A BIRD'S-EYE VIEW. This World War I–era card, part of a folder of postcard images of the city, features a bird's-eye view of East Summit. In the upper right corner, amid the trees, is Roosevelt School, facing Park Avenue.

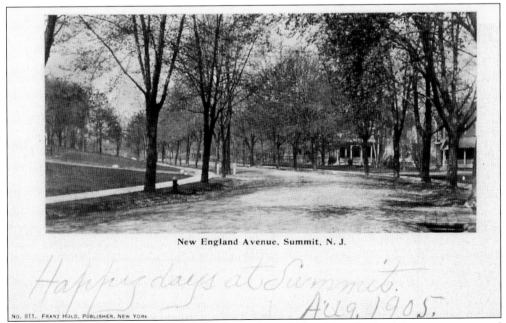

New England Avenue, Summit, N. J.

Happy days at Summit.

Aug. 1905.

NO. 811. FRANZ HULD, PUBLISHER, NEW YORK

HAPPY DAYS. This view of Victorian mansions that stood on New England Avenue was penned by its sender with the words, "Happy days at Summit. Aug. 1905."

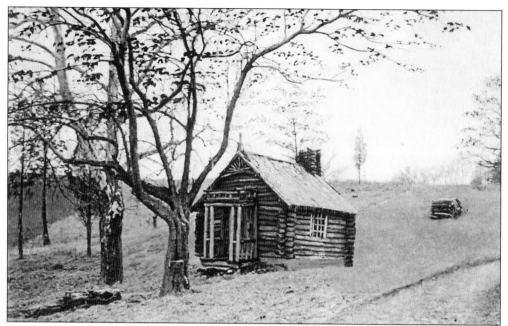

SAT ON A HILL. The log cabin depicted in this 1911 card was constructed on the south side of Springfield Avenue at about No. 170. Built over a spring, it apparently sat near the top of a hill and above a nearby pond and railroad tracks.

Behold here an exhibit of SUMMIT girls
All worth their weight in diamonds and pearls.

Huld's Letter Series No. 26. Copyright 1904, by Franz Huld, Publisher, New York

LO AND BEHOLD. Since this postcard carries a 1904 date from a printer in New York, it seems unlikely the young women pictured were actually from Summit. It contains the following poem: "Behold here an exhibit of Summit girls, / All worth their weight in diamonds and pearls."